PAINTERS
PAINTING

A CANDID HISTORY OF

THE MODERN ART SCENE, 1940-1970

In the words of Josef Albers, Leo Castelli,

Emile de Antonio, Willem de Kooning,

Helen Frankenthaler, Henry Geldzahler,

Clement Greenberg, Thomas Hess,

Jasper Johns, Philip Johnson, Hilton Kramer,

Philip Leider, Robert Motherwell,

Barnett Newman, Kenneth Noland,

Jules Olitski, Phillip Pavia, Larry Poons,

Robert Rauschenberg, William Rubin,

Ethel Scull, Robert Scull, Frank Stella,

and Andy Warhol

PAINTERS
PAINTING

By EMILE DE ANTONIO

and MITCH TUCHMAN

ABBEVILLE PRESS

NEW YORK

ACKNOWLEDGMENTS

Many have helped make this book possible: Michael Carlisle
and Irene Webb of the William Morris Agency; Fontaine Dunn;
Maxine Fleckner, director of the Film Archive at the Wisconsin
Center for Film and Theater Research (which houses the collec-
tion of de Antonio's films and documents), and Chuck Alger,
John Walsh, and Tim Hawkins of the staff there; Nancy Grubb
and Philip Grushkin of Abbeville Press; Fiona Irving of Leo
Castelli Gallery; and Max Marmor of the UCLA Art Library.

E. de A.

M.T.

Editor: Nancy Grubb
Designer: Philip Grushkin
Production manager: Dana Cole

Library of Congress Cataloging in Publication Data
Main entry under title:
Painters Painting.
 Based on transcripts from the film Painters Painting, made by Emile de
Antonio in 1972.
 Includes index.
1. Artists—United States—Interviews. 2. Modernism (Art)—United
States. I. de Antonio, Emile. II. Tuchman, Mitch. III. Painters Painting
(Motion picture) N6512.P27 1984 709'.73 83-21526
ISBN 0-89659-418-1

Grateful acknowledgment is made for use of the following material:
Excerpts from *POPism* by Andy Warhol and Pat Hackett, copyright © 1980
by Andy Warhol. Reprinted by permission of Harcourt Brace Jovanovich,
Inc. Excerpt from *Edie: An American Biography* by Jean Stein, edited with
George Plimpton, copyright © 1982 by Jean Stein and George Plimpton.
Reprinted by permission of Alfred A. Knopf, Inc.

First edition

This book and the film from
which it came are dedicated to the
memory of Terry de Antonio.

Contents

Preface

This book is a collaboration. De Antonio provided two
original texts: first, the complete, uncut transcript (over
seven hundred pages) of interviews done for the film
Painters Painting, and second, the film script itself, cre-
ated from the interviews. Mitch Tuchman edited the two
texts into this book. The original conversations were
filmed and recorded in 1970; hence, references to
exhibitions, events, dollar values, etc., belong to that
time and are not anachronisms.

If, in 1930, one had recorded Pierre Bonnard, Pablo
Picasso, Fernand Léger, and Marcel Duchamp talking
together it might have produced similar conversation.
And yet, until this book, major painters had never been
brought together to speak about their work in the com-
pany of professional observers: dealers, critics, collectors.
Here, many of the significant painters of the New York
School, 1940–1970, talk about how they paint, why they
paint, their brushes, the canvas, about edge and color,
about their influences, their ambitions, about where they
come from and where they belong in history. One aim of
the book is set forth in a letter from de Antonio to
Tuchman:

> *I want a conversational rather than a literary tone. The
> strength of the book is conversation. It's important,
> not as a defensive measure so that one can say, "Well,*

look, if they were writing it would be better." Not at all.
I never want to lose that improvisational, off-the-cuff
quality because it's better to me than art criticism.

E. de A.

M.T.

Cast of Characters

Josef Albers, *artist*

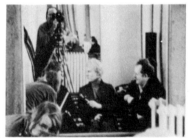

Emile de Antonio, *filmmaker*

Leo Castelli, *dealer*

Willem de Kooning, *artist*

Helen Frankenthaler, *artist*

Jasper Johns, *artist*

Henry Geldzahler, *curator*

Philip Johnson, *architect*

Clement Greenberg, *critic*

Hilton Kramer, *critic*

Thomas Hess, *critic*

Philip Leider, *critic*

Robert Motherwell, *artist*

Larry Poons, *artist*

Barnett Newman, *artist*

Phillip Pavia, *artist*

Kenneth Noland, *artist*

Robert Rauschenberg, *artist*

Jules Olitski, *artist*

William Rubin, *curator*

13

Ethel Scull, *collector*

Frank Stella, *artist*

Robert Scull, *collector*

Andy Warhol, *artist*

Introduction

Emile de Antonio

Long before this book there was the film, and before the film my life, in which I met the characters of the film and book. This is how it happened:

In 1946, as millions of Americans marched out of proper uniform into undress, the arts were in the air in New York as they had never been before. Ex-soldiers found time and money to make art (all the arts) on the G.I. Bill —expenses paid and a living allowance as well. The G.I. Bill was good for bar business, too. In painting, legends were already sprouting: Pollock, de Kooning, Kline. Crowds drifted after them to the Cedar and later to Dillon's, writers to the San Remo. We were out of one war and into a new one: the Cold War, Greece, the Marshall Plan, Korea, witchhunts. How could I have guessed that the tall, beautiful woman in the mink coat in graduate school at Columbia was married to a man who would help run the CIA in Germany? The heroes of Stalingrad (1942) were now our enemies (1946). And none of it made any difference to the new Bohemians who burst into Little Italy and beyond.

I joined that ex-G.I. Bohemian world. Not de Kooning's,

not Pollock's. Where I was, Picassoid forms swirled on Thompson and Spring streets. Glass in hand, I squinted at enchanted, inauthentic abstraction and realism—the canvases of my friends, young veterans. The idea of being an artist rather than making art had caught them. The talk was high, the spirits free, drink plentiful. Painters, even derivative painters, were tactile, had the best spaces, cared about good food. Anything was livelier than graduate school, where William York Tindall chased footnotes and Lionel Trilling studied gentility. Painting was chic. Did you see Picasso with his Afghan hound in *Vogue*? Lois Long, after sharing a breakfast of old-fashioneds with me and a softball game with the Italian kids in the playground at Macdougal and Bleecker, said, "D, what the hell, why don't *you* become a painter?" I knew what she meant. I couldn't. I preferred being an artist without an art, a perpetual student.

Long ago, my father had read to my brother and me, giving us after-dinner talks, telling us fireside tales about Napoleon, Homer, Giotto, Cimabue, Dante. He told me the *Iliad* in twenty-four installments when I was ten years old. Teaching it years later, I admired his structural memory of it. But then, he had read it in Greek and I taught it in translation. Throughout, the grain of his thinking was measured, rational, intellectual; it had prospered in a hothouse fertilized by Aristotle, not life. It was a paralyzing heritage. I heard its echoes at Harvard where the faculty was far distanced from my present. The masterpiece hung over me like a boulder on a string. Anytime I thought of doing anything I really wanted to do, like write a novel, I knew I would have to measure it against the Greeks, Dante, Balzac. So, I drank and drank and read and read and remained silent before the marble greatness. I never understood I was a prisoner until I was freed and I didn't know I was free until long after it happened.

The road to myself had to be subversive and indebted to chance. Lois Long and I met John Cage in Rockland County in 1954. We had a house, a piano, books, booze,

and time. John was thirsty, lonely, bored. We spent a year of nights storytelling our lives, our ideas, filtered through bottles of Irish whiskey. I stubbornly defended my father's learning without naming it. John always laughed. I learned what a demonic laugh was. I also learned to open my eyes and ears and to allow the beloved past to crumble. John laughed at the tales of his own unhappiness, failures, tries, mocking audiences, psychoanalysis, marriage, the thought of suicide. And finding a way. Zen. And mushrooms. Koans. I resisted it all. I still do. But I was changed. A frail enlightenment came to a materialist. I thought then: there may not be any god but surely John Cage is the devil. In the spring I watched the Army-McCarthy Hearings on television. Without John, I never would have been able to make *Point of Order* many years later. Without John, I wouldn't be writing these words. In his Zen I found America. Also, that art is what artists do. The give and take went on for over a year. In 1955 I produced my first event: a concert of Cage's. Like so much that was to follow in my life, it began with the police.

October 1955. The New York State Police: "Mr. de Antonio, are you producing the Cage concert in the Clarkstown High School tonight?"
"Yes. That is my intention. Why?"
"It's your intention to proceed?"
"Yes."
"Well, sir, the Weather Bureau is calling it a storm of major force. Trees are down across the roads, wires are down. Power could be out for hours. Our advice is: cancel it."
"Thank you. Okay, I'll let you know."
I drove to John Cage's house five miles north in Stony Point. Some of my own trees were down. I thought of firewood. Sticky, smelly pine. The concert was to include a new piece of John's to be played by David Tudor and Harold Coletta, and a dance performance by Merce Cunningham.

As I pull up the stony, muddy hill, I see John Cage through his window. I tell him about the State Police. We laugh, we agree that the storm will end and that the concert will go on. I was then chairman of the Rockland Foundation, an obscure arts foundation in Rockland County, northwest of Manhattan. It was still rural. John lived on the side of a mountain. Lois Long and I lived next to Conklin's, a 200-year-old, 200-acre apple orchard. Pomona was the name of the area, the Roman goddess of fruit trees.

The day before had been clear enough. John and I had inspected the Clarkstown High School theater, its seats, stage, sound system, tickets, and posters. The stage door hung open, and on the curved gravel driveway two men on their knees, nails in their mouths, hammers in hand, were finishing the sets. John said, "D, I'd like you to meet two friends of mine. This is Bob Rauschenberg and this is Jasper Johns. They are *both* very good painters." We shook hands and became friends. They lived together in lofts downtown on Pearl Street when it was dark, narrow, winding rather than dull and broad as it is today. They were the first painters I knew whose work I also knew from its beginnings and of whose gifts I was absolutely and immediately certain. I began visiting their studios frequently, we dined and drank together, and they took baths where I lived, both in Rockland County and the city. (Their lofts were tubless—loft-living in pre-boutique Soho meant whores' baths.) We talked constantly of painters and painting and food and drink. We played cards and drank. Once Jap (as Johns was known) made a dinner of mallards and wild rice. I brought Jack Daniels and invited some uptown people—Condé Nast editors, a few collectors —hoping to find Bob a gallery. Bob moved the big combine paintings so that Martha Jackson, who had an uptown gallery, could see them. She didn't. She fell asleep, drink in hand, nodding and snoring quietly as a combine went by. I woke her up.

Most of the dealers I knew were sluggish in ideas,

greedy, blind, and looking for complex and dramatic versions of the master-slave relationship with painters. I except Leo Castelli and a few others. At the time, many second-generation Abstract Expressionists were puzzled and outraged because I preferred Bob's and Jap's work to theirs. A poker game in East Hampton at Paul and Mimi Brach's (Helen Frankenthaler had invited me). They accused me of being an anarchist, a Dadaist, a wrecker. Maybe I *was* an anarchist; that in no way lessened the fact that Rauschenberg and Johns were making a new art and a beautiful one. New work never threatens the past, only the present that is yesterday.

The New York State Police were right. And wrong. There was a hurricane. It ended at 7:45. At 8:00 John and I stood in front of the Clarkstown High School waiting for an audience. Eight hundred empty seats. And then, bang! Two busloads of New York painters and friends found their way. At 8:30 all 800 seats were filled. The storm had moved to the concert hall, where the audience freaked, booed, laughed, stamped its feet, stomped out, cheered. It was wonderful. It *was* a new experience. No one could say: Ah, I've heard all this before. No one had.

When old films of mine like *In the Year of the Pig* (about the Vietnam War) or *Millhouse: A White Comedy* (about Richard Nixon) play today, some viewers ask: Why not make a film about the U.S. in El Salvador or Reagan's career? Implicit in the question is an innocence of form. I have already done those films. They may be useful starting points for others but not for me. I am finished with the form of them. Not at all the politics, but the form. Neither a social art nor a personal art can be original without reference to and reaction against previous forms. With *Millhouse* I made a film biography whose real theme is its form: a collage of Nixon's life in the media, in the cave of the winds, images and words contrived by him without respect to fact but servants to ambition. *Millhouse*

was formally rooted in New York painting and avant-garde music.

I had struggled long in the space between my politics and my enjoyment and support of contemporary New York painting. I loved the painting and tried to live my politics. My wife, Terry (she died in January 1975), suggested a film whose subject would be the New York painting of my time. It might resolve my problem, she said (in paraphrase): You smile whenever you read art writing in *Time* or *Vogue*. They're *about* painting. Your work isn't about subjects but is itself a subject.

I disliked the films on painting that I knew. They were either arty, narrated in a gush of reverence as if painting were made among angelic orders, or filmed with violent, brainless zooms on Apollo's navel, a celebration of the camera over the god. They revealed nothing at all about how or why a painting was made. Dislike of other films is not a bad place for a film to begin. There were problems nonetheless. The works were strewn across the world in different collections, and I didn't fancy trekking to L.A., Japan, Germany, and Italy for collectors who thought art was collecting.

Henry Geldzahler and the Metropolitan Museum of Art solved that problem in 1969 with an exhibition for the Met's centennial called *New York Painting and Sculpture: 1940–1970*. Henry collected 408 works by forty-three artists. The press called it "Henry's show" and treated it like a campy scandal, which made it look like one. It wasn't. It was the best show of modern New York painting ever hung. Contemporary works of such quality will never again be brought together on such a scale and in such appropriately grand space, perfect for filming. Modern art is more fragile than that of the Renaissance and insurance costs are too high. The paint and parts are inferior, particularly in the early works of many painters. The big works don't move easily and big collages contain elements never made to move.

The show's opening was October 18, 1969. There were

rock groups; the fashion world danced around David Smith sculptures. When I later filmed Andy Warhol, I asked about the opening:

> de Antonio *What did you like best in Henry's show?*
>
> Warhol *Well, I never did see Henry's show.*
>
> de Antonio *You never went?*
>
> Warhol *I went to the opening but I didn't go inside. I pretended to be Mrs. Geldzahler and invited everybody in. . . . So I never did see it and Henry doesn't know I never did see it. I'll probably see it in your movie.*

I met with Henry and Ashton Hawkins of the Met and we agreed that my company, Turin Film Corp., would have the exclusive right to film the exhibition. One stipulation on their part: we could film only at night when the museum was deserted and we had to pay to have three armed museum guards watch over us to preserve works from desecration. We spent many winter nights filming, and the guards were successful in preventing me from stealing *Aristotle Contemplating the Bust of Homer.* After I sent over a few beers and big meaty sandwiches, their chief said to me, "You making a film?" "Yeah." "Why film this garbage? It's awful [pointing to an Olitski]. Listen, take your crew down there about ten galleries and you can film Rembrandt." Weeks and hundreds of beers later, he came over and pointed at a de Kooning collage: "You know, that's not too bad."

I had always liked black and white film better than color. I liked its tone, shades, limits. I decided to film all the people in black and white 16mm. and all the paintings in 35mm. color. The film crew for *Painters Painting* was Ed Emshwiller, camera; Mary Lampson, sound; Marc Weiss, assistant camera. Hundreds of hours were spent lighting and filming the works I chose. Modern painting is more difficult to film than older work because often the frames

are metal. Under intense film lighting these cause "hot spots" that distort the image. All the beers and sandwiches proved useful in the late hours of the night as Emshwiller and I attached gaffer tape over frames to neutralize them. The guards looked away.

The film is personal. Why did I leave out Rothko, Gottlieb, Kline? I loved their work but loved Pollock, de Kooning, and Newman more. In Sagaponack one winter, a good and well-known painter who was in neither the show nor the film said to me over many drinks, "You know, I really like your political films but don't like *Painters Painting*." "Because you're not in it?" "Of course."

When I first knew Bob and Jap, they were poor. They didn't have dealers. They had to do commercial work to live. They kept it separate, calling themselves Matson Jones when they worked for Gene Moore doing windows for Tiffany and Bonwit Teller. *Vogue* photographer Richard Rutledge hired Matson Jones to make a snowfall in his studio so that model Ruth Ebling could stand shuddering in a slip. The ad won an Art Director's Club award.

Jap called one day and said, "D, what are you doing next Thursday, the one after this one?" I said, "Why Jap, you know perfectly well I have no idea what I'm doing that far ahead. Why?" I went that Thursday. All the paint cans, rags, old clothes and coffee cups, papers and bottles had been cleared away. Floors mopped, walls painted white, more beautiful than any gallery. And on the walls were the works that were to sweep the art world before them: encaustic flags; plaster casts in boxes over targets and flags; a green target; numbers. I had seen all the works singly, but this showing was different. Bob was as happy as Jap that it was beautiful and that I loved it. The relationship between them was one of wit, affection, solicitude. Each spoke for the other, defended the work of the other.

By 1970 Bob and Jap were separate and hostile. Once they had been their own club, but successes stretched the friendship until it tore. Rauschenberg was older;

success had come to Jap first. Toward the end of their days together we spent a Labor Day weekend together in East Hampton. Tina Fredericks had a tall willow over her wide green lawn. Jap had a marmoset on his shoulder. Bob, Jap, and I had too much to drink. The marmoset was frightened by a dog, ran free, and reached the top of the swaying willow. We called, sang, whistled, tried to climb the tree, failed. The marmoset came down when it was bored; we played hearts over Jack Daniels.

Jasper's studio in 1970 was a bank—the Provident Loan Society at 225 East Houston Street. Filming in a bank makes a sound problem, since banks reverberate. Jap greeted us, and he and I sat down at a round table while Mary, Mark, and Ed set up the lights, camera, and sound. Jap said, "D, what are we going to talk about?" "Well, you know I believe in history. The Flag. The Target. All those. How they came about." "But D, we did all that over many nights." I was hungover. I had some Bloody Marys, Jap, Jack Daniels. I felt we were ready to film. Jap painted with the radio on. Mary, wearing headsets, pointed to the radio. I walked over and listened to the Beatles through the headsets. They were loud, but Jap could still be heard. I said, "Okay, let's go just as we are." Jasper is an intellectual painter who has read Wittgenstein. His language is precise. I wanted those seeing the film to strain to hear him. Velvet synch sound simply accedes to our national brainwashing. TV is passive listening/viewing. I wanted the audience to listen actively.

We filmed Bob in his studio on Lafayette Street. The studio had once been an orphanage. Attached was a chapel. It was there I decided to film him. I wanted Rauschenberg high up in front of the tall window, slums and firescapes behind. (Cutting off sunlight with a tenement makes it possible to shoot in front of a window.) Sixteen mm. film is ordinarily shot in ten-minute reels. Each reel change involves a pause. At each of these pauses Bob's Japanese assistant handed him a fresh Jack Daniels. I, too, was drinking with each reel change. The

day ended with a night of drinking and poker. Marc Weiss filmed all the poker. The night itself became a lost memory.

Carl Andre wrote to me about the film in 1980: "My favorite sequence is Rauschenberg sitting on the stepladder in his chapel drinking himself into a state of grace in fading light—you achieved an extraordinary unity of style that allowed each of the principals to be very much him or herself—that kind of transparency of style is so rare, like Turgenev."

In the spring of 1957 Tina Fredericks and I sped down to Princeton in a racing-green Jaguar to spend a weekend with Stephen Greene and his wife, Sigrid de Lima. Steve was artist-in-residence at the college. Drinks before us, we gossiped about New York painting, galleries, collectors. Steve told us about a young painter who worked with him, the best he had ever seen. His name was Frank Stella. And only today, June 12, 1983, Steve told me this story: A professor came to Steve and said, "Look, I have Frank Stella as a student. He came to my first class and stayed fifteen minutes. It was the only time he came. You know I have no option but to fail him. If I do, he won't graduate. I have heard you think he is a genius. If you really think that, I'll pass him." Steve said, "He is."

Frank came to New York in 1958 and we became friends. He was fascinated because I knew Jap. Frank wanted a gallery, and he asked me to bring down Eleanor Ward, of Stable Gallery. The Stable Gallery was a magic space—wood in the steel, stone city. Long before, the rich had stabled their horses there. Not stairs but a ramp between floors, and the smell of horse piss on damp days. Frank's loft was very small. He brought out the black paintings. Eleanor whispered, "D, why did you ever bring me here? I hate this, let's go." We left. Within a year Frank joined the Castelli Gallery and was in Dorothy Miller's show at the Museum of Modern Art, *Sixteen Americans*. Some of the others were Louise Nevelson, Jack Youngerman, Bob Rauschenberg, Ellsworth Kelly,

and Jasper Johns. Frank was twenty-four years old.

Frank's work, clean and direct, was a litmus test for middle-class sensibility. A witty, charming psychoanalyst friend of mine came by one wintry February day in 1961. My windows were open, big soft flakes of snow falling. She had brought me a can of ether from Carnival in Brazil. I don't sniff ether. She looked at the small black Stella on my wall and said: "What is it?" I told her. She laughed and sprayed it with the ether. Her husband laughed. Two tolerant liberals were turned into philistines. Not even Nixon could have moved them so deeply. Puzzled, angered, I walked to the window and saw a young neighbor, Ann, walking in the snow. She waved, and I invited her in and gave her a drink. She worked for the American Federation of Arts. She laughed an ivy laugh, "Oh, D, *you* did that painting, it's just one of your art jokes." She poured her drink over the black Stella. I threw them all out, and the next morning the husband appeared at my door with a small Motherwell, an atonement from his collection.

It was from Frank that I learned firsthand that in the age of mechanical reproduction, modern painting could not be copied or imitated like an Old Master. Take Titian. It takes a scholar's eye, sometimes an X-ray, to know a painting by Titian from one by his school or apprentices. It's much harder to copy a de Kooning or a Stella or a Rauschenberg. Ordinary reference points are not there. First of all, the new paint—industrial paint, house paint—is mass produced and dries in different shades, ages differently. Common materials are inconstant, and it is harder to make a copy that will retain a likeness. Frank made me another small black painting. It was exactly the same size; the interstices between the unsized canvas and the paint were the same, but it wasn't the same painting. Frank couldn't copy himself. I hung them side by side for over a year; they became clearly different in tone and shade. The same point was made by Rauschenberg, also unintentionally, in *Factum I—Factum II*. (What looks imitable is singular, stamped with an original and inimita-

ble presence. What *is* imitation and imitable are Tom Wolfe's drawings in *The Painted Word*.)

Frank's studio, where we filmed him, was on West Houston Street near Varick. It ran a block south to north and had been the Firestone Tire Company warehouse. (By the time I was editing, Cinda Firestone was working for me as an assistant editor.) That 1969–70 art season was Stella's year: two weeks after Geldzahler's show opened at the Met, Irving Blum opened a one-man show of Stella's work in Los Angeles, followed on December 18 by a one-man show at Castelli. In the spring of 1970 Bill Rubin produced MOMA's Stella retrospective. We filmed Frank at the Met, at MOMA, and in his studio. He was congenial and organized. A sense of history and a Cuban cigar make for better footage than ahistorical staring at the floor. He could be edited without force because he knew where he had been and where he was. In his studio, we filmed Frank before a work in progress, one of the Protractor series. When the image of the work dominated, I used color and Frank's voice; when Frank's voice and gesture worked better, I switched to black and white.

I met Andy Warhol in 1958 through Tina Fredericks. When she had been art director at *Glamour*, Andy appeared with his portfolio. Tina looked at it and said, "Mr. Warhol, you're very gifted. I see gifted people every day. I need some drawings of shoes. I need them tomorrow morning at 10 o'clock. Can you do them?" Little did she know the wellsprings she stirred. Andy not only loved shoes, he loved feet. His house was full of shoes. The first day I was there I picked up a pair. "What are these? A prop of some kind?" They were Carmen Miranda's. And the next day he appeared at *Glamour* with a stack of shoe drawings that propelled him to money: I. Miller, the *New York Times Magazine*, *Vogue*. He was famous before the public knew him. He bought a townhouse and collected paintings. He hid his paintings but showed them to me: Johns, Fairfield Porter, Rauschenberg, two great Magrittes.

Andy was New York and America, the coal-miner's son who dines with the golden. I love his work and don't like his friends: old Hollywood stars of dubious parvenu politics. But then, Dostoevski beat his wife; Stendhal and Balzac were toadies.

Bob Rauschenberg in *Edie* tells a story of meeting Andy: "I first met Andy, very shyly, on somebody's back porch in mid-Manhattan with D—Emile de Antonio. D had already been instrumental to Andy in a number of ways: he convinced him that he had the courage and the talent to give up his commercial-art success. Andy had a kind of facility which I think drove him to develop and even invent ways to make his art so as not to be cursed by that talented hand. His works are like monuments trying to free himself of his talent. Even his choice of subject matter is to get away from anything easy. Whether it's a chic decision or a disturbing decision about which object he picks, it's not an aesthetic choice. And there's strength in that."

When I first knew Andy he lived in a house at Eighty-ninth and Lexington, next door to the National Fertility Institute. He came to small dinner parties at which I served smoked salmon, Dom Perignon, and grass. Andy did extraordinary menus. I wish I had one, I always gave them to guests like David Winn or Bobo Legendre. I introduced him to a fashion model whom I later married. Andy was fascinated—he stared at her and said, "Why, D, she looks just like David. Why don't you marry David?" Andy remembered everything; he read every gossip column. He wrote fan letters to Tab Hunter. Of course, he had always wanted to be a painter. He masked his past; he denied he ever went to college; but he did—Carnegie Tech; he graduated at nineteen. I realized early that he knew the answer to every question he asked. The first day I met him, he said: "Tina tells me you know everything. How did World War I begin?" I started about Sarajevo, Marxist history, etc. Then I looked at him and thought of his being Czech and what a large trout I had been

to accept his bait. I never did again. I helped Andy;
I enjoyed it without regret.

His own version in *Popism* is best:

> *After I'd done my first canvases, D was the person I*
> *wanted to show them to. . . .*

> *At five o'clock one particular afternoon the doorbell*
> *rang and D came in and sat down. I poured Scotch for*
> *us, and then I went over to where two paintings I'd*
> *done, each about six feet high and three feet wide,*
> *were propped facing the wall. I turned them around*
> *and placed them side by side against the wall and then*
> *I backed away to take a look at them myself. One of*
> *them was a Coke bottle with Abstract Expressionist*
> *hash marks on the side. The second was just a stark,*
> *outlined Coke bottle in black and white. I didn't say*
> *anything to D. I didn't have to—he knew what I wanted*
> *to know.*

> *"Well, look, Andy," he said after staring at them for a*
> *couple of minutes. "One of these is a piece of shit,*
> *simply a little bit of everything. The other is remark-*
> *able. . . . You ought to destroy the first one and show*
> *the other." That was an important afternoon for me.*

Andy's search for a gallery, again recounted in *Popism*:

> *It was D who finally got Eleanor Ward to give me my*
> *first New York show, at her Stable Gallery. . . . D ar-*
> *ranged to meet Eleanor at my studio one evening in*
> *'62. We sat around talking for an hour or so, having a*
> *few drinks until D said bluntly, "Well, come on Eleanor.*
> *The point of all this, after all, is are you going to give*
> *Andy a show or not, because he's very good and*
> *should have one." She took out her wallet and looked*
> *through the bill compartment. Then she held up a*
> *two-dollar bill and said, "Andy, if you paint me this, I'll*
> *give you a show. . . ."*

We filmed Andy in his studio at 33 Union Square West—a long space, most of a floor with floor-to-ceiling windows on the east and west. I knew long before the crew arrived exactly how I wanted to film him: Andy and I on a park bench between the two mirrors, Emshwiller standing behind us shooting over our heads. Andy improvised by adding Brigid Polk to the scene. Andy lived in mirrors. (He was the prince of voyeurs. Not a peeper at all. People came to Andy to do whatever it was they wanted to do so that Andy could watch or film.) Thus, in long shots, Emshwiller could be seen filming; Mary doing sound; and Brigid, Andy, and I talking on a park bench. As we filmed and talked, Andy audiotaped everything. At the time he was audiotaping his entire life with others: Tennessee and Edie, Baby Jane and Nureyev. There is a social history of strange times in Andy's tape collection; enough to make five writers rich and famous. The atmosphere at Union Square was so odd that the crew didn't enjoy Andy as it had Bob, Jap, and Frank. His brush with death a couple of years before, his chic, his quiet voice, his eyes that revealed so little—all this made them ill at ease.

Good independent film crews are brought together for single shoots. Most independents work for others hoping to make their own films: Mary Lampson's *Until She Speaks* has just been released by PBS; Cinda Firestone made *Attica*; Marc Weiss is head of the Media Network; Ed Emshwiller does experimental television and is provost of the California Institute of the Arts. They aren't hardened like TV news crews, which do the same thing day after day, or advertising crews, which will do one hundred takes of a beer bottle. The independents don't work as often —they don't want to. They become involved with the people they shoot.

The crew loved Barney Newman, with his monocle and moustache. Even the camera loved him. He was more American than Myles Standish. Impatient, he had waited long. He didn't give an inch. In the '30s he had run for the

mayorality on the Trotskyite ticket. Newman didn't need critics; he didn't need museums; the beautiful old walrus had triumphed. We loved his camera presence, his sharp sense of himself, the flash awareness of what he was saying and giving, his pride, his quick anger, his glass of what Annalee assured us was water, and one cigarette after the other with his emphysemic wheeze.

He died a few weeks after we filmed him, and Mary worked hard to cut out the wheeze without wrecking the rhythm of his speech. She did it, too. After his death we filmed the work in his downtown studio. His painting was majestically lean.

Loneliness and rejection breed organization, manifestoes, clubs; success yields atomization and a different loneliness. The Club of de Kooning, Motherwell, Phillip Pavia—whether it began informally in the old Waldorf Cafeteria under the El on Sixth Avenue or whether it dates later from Eighth Street—was formed because New York painters had no audience except themselves. They were excluded from the frenchified, official art scene as well as from realism. They needed roots and connections with other new ideas. Cage spoke at the Club and so did Cunningham. Its members shared a common view of abstraction. They stood for a new New York art. Later, Bob and Jap and a few friends became a club, and even later there was a loose confederation in the color-field school. By the time the followers of de Kooning and Pollock were in art school, the Club started to wither away. The Club became a prison for some of the second-generation Abstract Expressionist painters, which may be why they turned to photo and other kinds of realism.

I arbitrarily excluded sculpture from the film. I didn't know as many sculptors, and the film was to be only about two hours long (it runs exactly 116 minutes). Although he is a sculptor, I filmed Pavia because he was a key to the Club, to that history going back to the WPA, to the influx of European painters who fled Hitler; be-

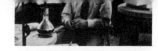

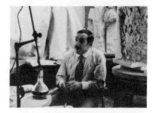

cause of the magazine he edited, *It Is*; and because he
knew and worked with the painters who are the subject of
the film.

 Pavia's studio was at 810 Broadway, near enough to East
Tenth Street, which had been the heart of abstract New
York work. A beautiful, airy, graceful space; with no tall
buildings to block the light. Pavia was wise, strong,
generous. He wanted to talk of stone and his work. We
walked through and around his sculpture, filming it al-
though I told him that it wouldn't be in the film, that I
would use it only when it was a shot in which he spoke,
that I would probably use his voice over other material.
There is a cruelty in the seamless, collage documentary
that I began because collage is accident in part only. I
knew many of the pieces I needed. I would need narrative
without the Olympian boredom of narration. Pavia and
the critics I filmed filled that space.

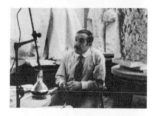

 Tom Hess lived in a big house on Beekman Place. It
was the late part of a winter day, dark, and through the
two-story window traffic could be seen moving up and
down FDR Drive. The walls were hung with major work of
the New York School. Hess was the editor of *Art News*, the
author of books on de Kooning and Newman, and close
to both of them. He has died since we filmed him. He was
easy to film; he knew much; he drank as much as anyone
we filmed and remained coherent and accurate. I liked
him. He was an enthusiast. He liked the work, the people
who made it.

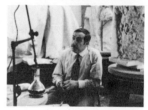

 Between Clement Greenberg and Harold Rosenberg,
I had to choose one. I chose Greenberg. He was closer
to the younger painters; he was also the only person who
asked to be paid. I flinched, expecting him to name a big
number. It was $100.00. (The canceled Turin Film Corp.
check is in my archive at the University of Wisconsin.)
Greenberg's apartment was on Central Park West. He
spoke very slowly, very quietly, magisterially, ex cathedra.
At the time we filmed him, he wrote sparingly; his power
was unique. An essay by Greenberg influenced collectors

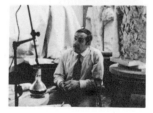

as much as it did painters. Time is always an embarrass-
ment in film, there are those boring moments when lights,
camera, sound recorder are set up. Greenberg made us
feel that each of those moments was lost to history. The
crew did not like him, which made no difference to them
or to him. By the time we filmed Greenberg, we were
working well together, we had shot thousands of feet of
film together; we would never work together again and
we all knew that, too. All that mattered: Greenberg on
camera was very good; prickly, contentious, and good.

Negative voices are necessary, too. We filmed Hilton
Kramer at the pre-word-processor *New York Times*, where
he was the art critic. I had known Hilton for a long
time—not well, but enough to know that he disliked
Henry's show (too trendy); that he disliked the New York
painting I liked. In those days, as now, he was more
comfortable with realism. He also disliked my politics. It
did seem bizarre to me that he still believed that Pollock
belonged to the School of Paris, that Stella was too easy,
Andy too commercial, etc. I needed that anti-narrator
kind of voice. He provided it.

Helen Frankenthaler's studio was an East Side house.
She wore a dress for the filming. I told Helen what I told
everyone else we filmed: my questions would not be in
the film. I needed long answers, inclusive answers, an-
swers that referred to my questions, so that I could cut
from one person to another. Film is the cheapest part of
filming. The method was also to ask everyone some of the
same questions: Is painting dead, as Warhol said? Com-
ment on Darby Bannard's statement: "No high-minded
painter of the last fifty years has been able to come to
terms with his art without coming to terms with the
problem of Cubism." When did you start to paint? How do
you use the materials of painting and why do you use or
not use acrylic? It was by moving back and forth from the
technical to the general, from the general to the personal,
and by knowing many of the answers, that I was able to
write a script as I filmed. Both the film and the book came

from hundreds of pages of raw material generated by my questions. There is no pretense to objectivity. I ask my questions. I state my views from time to time. I don't presume to state the artists'.

I belong to the Left and there isn't a single Marxist in the film; there isn't a black painter; there is only one woman. I'm not comfortable about it, but it was the art world as I knew it. The contradiction is apparent and its resolution isn't in my hands. Helen knew she was the only woman in the film. I asked Helen about being a woman, and her answer seemed thin when we were cutting the film. I now see that she was probably more honest than I was.

> de Antonio . . . what are the problems in being a painter and being a woman, or aren't there any?

> Frankenthaler I think that there are problems for everyone. . . . Relatively, I feel these problems less than other women might feel them. . . . I feel it's a problem to be anyone today. . . . Along with many other things I am glad that I am a woman. . . . I feel that the issue is to try to make beautiful pictures. And all the things that one is are brought to bear in the making of one's work.

The best interview I ever shot was with Louise Nevelson. She was witty, angry, and had that high-energy film magic that certain actors have. Her timing was experienced, precise. She wasn't afraid to be outrageous. She attacked the leading women of American fashion and pointed to her own clothes, which she designed herself. She attacked Clem Greenberg and most of the art establishment. Henry hadn't put her in his show. I felt she belonged there. But she made sculpture and I was doing a film

whose subject was painting. I was able to film much of
her work. I offered the material we shot to Mary and
Cinda. It's all still there in my archive. It's good enough
for the start of a film on Nevelson. Nevelson has mel-
lowed over these fourteen years, and if anyone does do
a film on her, I suggest she look at it.

 I will not write about any other painters in this book nor
about collector Robert Scull, but I cannot end without
Leo Castelli. What his enemies say may be true: he loves
the power; he loves the money. But he loves the work
most and well. And he has a very deep sense of the
history he has lived. As work becomes bigger and bigger,
he opens newer and bigger galleries. His twentieth anniver-
sary as a dealer was celebrated at a party in Frank Stella's
house. A catalog was contributed by the staff and artists of
his galleries. Andy Warhol did the cover. It was March 18,
1977. Leo signed my catalog: "For D. In memory of his
first visit to my gallery on February 1, 1957. With Love,
Leo." His space then was at 4 East Seventy-seventh Street,
small, beautiful. The first show came from work he had
collected: de Kooning, Delaunay, Dubuffet, Giacometti,
Hartley, Léger, Mondrian, Picabia, Pollock, David Smith,
van Doesburg.

 In 1973 I wrote the introduction to a catalog for an
exhibition of New York work traveling to the Moderna
Museet in Stockholm. Pontus Hulten was curator there. I
had first encountered his name in an article entitled
"Three Great Painters: Churchill, Hitler and Eisenhower,"
which he had written for Alfred Leslie's magazine *The
Hasty Papers*. I knew that someday I would become the
friend of the man who wrote such a piece. I did, and we
went sailing in the Baltic. I finished my introduction to
Hulten's catalog with two lines that still express my belief:
"As for the dilemma between art and politics, I still
believe in an art of quality and radical politics. The two are
not incompatible."

Prologue

Philip Leider

We made portraits of ourselves when we had no idea
who we were. We tried to find God in landscapes that we
were destroying as fast as we could paint them. We
painted Indians as fast as we could kill them, and during
the greatest technological jump in history, we painted
ourselves as a bunch of fiddling rustics.

It was exactly at the moment when we finally aban-
doned the hopeless constraint to create a national art that
we succeeded for the first time in doing just that.

If one finally had to say what it was that made Ameri-
can art great, it was that American painters took hold of
the issue of abstract art with a freedom they could get
from no other subject matter.

1. How can you be an artist and still be American?

Hilton Kramer

The whole modernist movement had been under terrific political pressure, well, I suppose, since the Constructivist movement was suppressed under Stalin in the 1920s in Russia. Then modern art was suppressed under Mussolini in Italy, then after 1933 in Germany. After 1933 Paris was really the only place—Paris and London; London didn't count for as much then. It was in that rather small margin of Western Europe that modern art was even possible as a political activity. And when Hitler invaded Paris, the remnants of the French avant-garde came to New York as refugees. In a sense, the balance never restored itself.

Thomas Hess

During the war, airplane loads of Surrealists and famous European artists came to New York. There were people of every variety. They came to New York and

established themselves as part of the New York art world. Peggy Guggenheim opened a gallery on West Fifty-seventh Street and showed American artists along with the established Europeans. There was Mondrian and there was Baziotes. There was Max Ernst and there was Gypsy Rose Lee, who had a show, and Joseph Cornell and Motherwell, and Pollock, Rothko, and Hofmann. New York suddenly changed from a provincial backwater of Paris to something of its own with immense resources.

Henry Geldzahler

For the first time, when the Europeans worked in New York—one thinks immediately of Fernand Léger, Piet Mondrian, Chagall, Dalí, Duchamp, Breton, Tanguy, and many others—it became clear to the American painters and sculptors that it wasn't necessary to go abroad in order to create art.

Hess

Paris, of course, was sealed off under the German occupation. No one knew what Picasso was doing. No one knew what Matisse was doing. In this sense, the immediate past was off the backs of the American artists. Then, when the war was over and the paintings done in Paris during the war were shown here, to everyone's astonishment they didn't look so good. In fact, they seemed to have missed the point that the Americans were struggling for. The French didn't even seem to realize that there was a crisis, that there was a problem.

Geldzahler

It's not unusual for a style to get its name from a city. One thinks of Florence and Rome in the sixteenth century and of Paris in the early decades of the twentieth century, for example. The New York School, as it has come to be called, produced the first American painting and sculpture to command international critical attention.

Hess

The problem was how can you paint in the modern world? A man like Picasso or Matisse or Miró, the great artists, when they paint, they slam the doors behind them. It's impossible to follow and be a little Miró. Contrast this with the Renaissance situation or the eighteenth-century situation for that matter, where a master could follow his master improving, making changes. In modern art the immediate past was closed off to the follower. What the French had been trying to do was make eclectic combinations: use Matisse line with Bonnard color, use Picasso violence with Matisse's serene, luxurious properties. The Americans realized you couldn't move in that wedge.

Geldzahler

Another great factor in the early 1940s was actually a backwash from the effectiveness of the WPA, the Works Progress Administration, one of President Roosevelt's New Deal projects.

Phillip Pavia

The main function of WPA was Roosevelt thought we should decorate all public buildings, which was a marvelous idea. We should hire these artists by the week, which he did—$23.90—and he hired a lot of us. You had to have some background to be in on it; we were all trained and schooled. There weren't that many artists. It was a very lonely profession at the time. So we decorated airports, public schools, terminals, whatever you had; that was the function.

Willem de Kooning

I worked for Léger, for instance. I was an assistant, and he was very surprised that he could find so many artists who could assist him, which would have been very difficult in Paris. It had something to do with the WPA art project.

Somebody made an arrangement where Léger could be—naturally it couldn't be in the art project, because he was not a citizen—but he would be in another kind of capacity, as a leading force, and he had in mind to paint large murals on the French Line, on the French pier. They had it arranged so that he could do that, and he had six assistants who were on the WPA art project in some way or other. So he wasn't on it; he did it for free. But then the French Line, in spite of Léger, didn't like the idea, so that didn't go through.

Geldzahler

In this way, for the first time, there appeared in America an "artists' union," so to speak. The artists had common cause together; they had complaints, they had meetings, meetings that resulted in loose associations and in the foundation of schools and in something called "the Club," which became terribly important as a forum for new, radical, innovative ideas among the artists. This became a very important factor in the kinds of communication that became possible among artists, artists who had been isolated in their own studios previously but who now had intercourse with each other.

Pavia

The refugees were around during the war. They were "the artists"; we all looked up to them. We'd stand on the street corner and see them going to dinner and see them coming from a social party. Around the corner was Hans Hofmann's school. Everybody went to his school and picked up the language of Hofmann. With that started this nucleus. Then the refugees slowly disappeared. They went back to Europe. Then we were on our own.

We looked around for a club for about two years, and when Motherwell closed up his school on Eighth Street, we opened up nearby. That was the beginning of the Club—around 1949, early in September or October. It was a whole art world in one—curators, photographers,

architects—only a few of us, but it was a whole art world. Maybe about 140 or 150 people, but never more than that. We were very intimate.

First, the Club was built around Bill de Kooning, Franz Kline, myself, and Tworkov. There were about twenty-five of us who were the nucleus.

de Kooning

I felt a certain depression over there [the Netherlands]. I felt caught, small nation. I went to Belgium and worked for a while. The American movies, Paramount movies, all those movies, Warner Brothers movies . . . America seemed a very light place. Of course, I didn't know that the movies were all taken in California. But everything seemed to be very light and bright and happy, particularly the comedians, like Harold Lloyd, Charlie Chaplin, Tom Mix. I always felt like I wanted to come to America, even when I was a boy.

The first one [to come] here was Hélion, Jean Hélion. He wrote letters. He told me that all the artists had come to New York, particularly Mondrian (he was worried about Mondrian), but they hadn't. They stayed in Paris. Then when they did come, when the war really got serious, he immediately went back and joined the French army. I thought that was marvelous. I thought that was very funny.

I came here without any money at all, and I immediately started working as a house painter. I wasn't being taken advantage of. In other words, I got the same pay, and, I guess, with one week's salary I could buy a suit, a lot of underwear, socks, shoes, a hat. It would have taken me years to do that. The whole structure of life was different.

Hess

When de Kooning first came to this country and started to paint seriously in the late 1920s, early 1930s, there was practically no American art world. For all intents and purposes it didn't exist in the sense of modern art.

There was a provincial tradition, which was lively, but the modern artists were entirely dependent upon European sources. De Kooning came over here as a European, a trained European artist, and was caught in the bind that all the other American modernists were trapped in.

de Kooning

A lot of artists all during the Depression period when they had leanings toward either being a socialist or a communist or a fellow traveler, they were more or less trying to keep convinced to make paintings applicable to the period: I mean, strikes and poor people. It had an enormous effect upon people. But I don't think painters have particularly bright ideas. Not such a bright idea for Monet to paint those haystacks at different hours of the day. Leonardo da Vinci said, when you lack ideas for composition, look at tracks. So I look at my own tracks, and whenever somebody comes out of it, most of the time it's a person from this neighborhood [The Springs], not Lily Pond Lane [in East Hampton].

Pavia

Our favorite thing at the Club was the panels where we'd get five people to talk about art. We'd throw up a subject like "What is the situation in art today?" and then before you knew it, there would be a three-hour discussion. Bill de Kooning and Franz Kline . . . a lot of brilliant exchanges, and there we cleared the air. We'd ask somebody from the audience to join in. Ad Reinhardt, for instance: he was very prominent and always willing, always joined a lot of panels. Then there was a free exchange between the audience.

We had a lot to say, and we did pick up the cudgel of abstract art, which was left behind by the Europeans. They dropped it, and we picked it up and carried it on.

Barnett Newman

About twenty-five years ago for me painting was dead.

Painting was dead in the sense that the situation, the world situation, was such that the whole enterprise as it was being practiced by myself and by my friends and colleagues seemed to be a dead enterprise. There was the war and Pearl Harbor and the Battle of Britain, and painting, you might say, existed in three phases. There was the kind of painting that was trying to make the world look beautiful, you know, painting flowers or girls playing the cello. There was also the kind of painting that was trying to be pure, based on Cubism, where the actual world didn't exist and the so-called paradise of pure forms functioned. It seemed to me that these things were futile enterprises for a man. On the one hand, you had these Cubist purists. On the other hand, you had the folklore artists who were doing the old oaken bucket: Tom Benton and all those fellows out West. The Surrealists were also kind of beating a dead horse, because they were creating an imaginary world, although it was actually more relevant than anything else in terms of my experience. They were at least painting or showing the possibility that you could paint something that was meaningful. From my point of view, I suppose, the subject matter of Surrealism, that magic, was essentially a phantasmagoria and a preoccupation with certain aspects of the contemplative life, of sexual symbols and Marxist ideas, which were so private that the actual material did not really interest me. I am the first one, however, to tip my hat to those men in that they did show that you really didn't have to paint landscapes.

What it meant for me was that I had to start from scratch as if painting didn't exist, which is a special way of saying that painting was dead. I felt that there was nothing in painting that was a source that I could use, and at the same time I felt that the whole situation was such that we had to examine the whole process.

I felt the issue in those years was: What can a painter do? The problem of the subject became very clear to me as the crucial thing in painting. Not the technique, not

the plasticity, not the look, not the surface: none of these things meant that much. The issue for me—for all the fellows, for Pollock, for Gottlieb—was what are we going to paint? The old stuff was out. It was no longer meaningful. These things were no longer relevant in a moral crisis, which is hard to explain to those who didn't live through those early years. I suppose I was quite depressed by the whole mess.

The best distinction was made by Professor Meyer Schapiro, who was talking about subject in painting. He made the distinction between the subject of a work and the objects in a work. For example, people think that Cézanne's subject was the apples. Well, it's possible to argue that that's what it was, and for a long time I was very antagonistic to those apples, because they were like superapples. They were like cannonballs. I saw them as cannonballs. Even though my painting, as it developed, didn't have any of those objects, that did not necessarily mean therefore that there was no subject there.

Some of us did remove all that object matter from the work: the lazy nude, the flowers, the bric-a-brac that in the end had been reduced to a kind of folklore. We introduced a different subject matter that the painting itself entails, that the painting itself projects. In that sense, I think, it has more relevance (which, of course, is a popular word today). It has more meaning in relation to the real issues involved in human life than all the little things that for hundreds of years everybody was involved in trying to make beautiful. People were painting a beauti-ful world, and at that time we realized that the world wasn't beautiful. The question, the moral question that each of us examined—de Kooning, Pollock, myself—was: What was there to beautify? And so the only way to find a beginning was to give up the whole notion of an external world, so to speak, that one could glorify and to put oneself into the position of finding this possibility, which people call a medium, of saying something that would be important to oneself. And that's what I mean by

beginning from scratch. We couldn't build on anything. The world was going to pot. It was worse than that. It was worse than that.

Robert Motherwell

If one generalized, one would say that the tendency was for native New Yorkers—well, *native* is not right—for artists who were really embedded in New York City to be very anti-European. The artists who came from the provinces —California, the Middle West—plus Gorky and de Kooning, who were grown men when they arrived in America, were more pro-European. To put it psychologically, one might say that some of the Abstract Expressionists wanted to shatter Europe and that others wanted to continue Europe—and when I say *Europe*, I'm using it as a metaphor for the modern movement.

I was definitely a continuer. That is to say, what I think is original is what originates in one's own being and one doesn't have to try to be original. Working within an established tradition, one's originality will inevitably show itself. I think Pollock felt very parallel.

The notion that one has to come to terms with Cubism depends on what one conceives Cubism to be. If it is regarded as a specific structure, then I think many artists after Cubism were very much damaged by trying to take over this particular structure. If Cubism is regarded more broadly as an effort to purify painting, that is to say, to get rid of all the tricks and devices and corn that characterized establishment art for so many years during the nineteenth and the beginning of the twentieth centuries, yes, one is involved in it.

Throughout my life, the twentieth-century painter whom I've admired the most has been Matisse. But at that particular moment when I was beginning, I was very taken, more unconsciously than consciously, with Mondrian. At the same time, I was in the middle of the French Surrealist milieu and very aware of the problems of the unconscious, of free association, of automatism, so

that I was trying, as I suppose I have ever since, to integrate what on the surface might seem very disparate elements, though I think it is possible on occasion to integrate them.

I think Pollock in his automatism made his integration of the same circumstances, Baziotes did in his way in his automatic dream pictures, and I did it in my way.

Geldzahler

Pollock felt very strongly, and he made the statement, that the best art had been produced in France in the past hundred years. He was frank to admit it, but he said that the influx of European artists didn't mean so much to him as it did to some of the other artists because it was Miró and Picasso specifically whom he admired and neither of them came to New York during that period, though their ideas were carried by the other artists.

Pollock felt, and said explicitly, too, that it was time for painting to go from the easel, from the small picture to the mural, to the wall-sized painting. He did a painting here on the floor, working on it from all four sides, the way the Navajo Indians did their sandpainting in the desert. (Pollock was from the West and knew about the Navajo Indian tradition.) He painted on the floor from all four sides, and he painted gesturally, not just the brushstroke or the wrist moving but the whole arm moving across the canvas. In his beautiful *Autumn Rhythm* [1950], you can see how the gesture encloses itself again and again to make the entire rhythmic design of the picture. It isn't just arbitrary. If you look at the corners, at the bottom, to the sides, you see that the design continues to close in and refer to itself. It's a continuous, gestural, balletic design, like choreography perhaps.

In this sense the artist was working in a new way, a way that influenced the other painters of his generation in what Harold Rosenberg called, in a phrase that is very famous now, "action painting." The painting, the mural, the canvas becomes a field of action in which the artist

makes his gestures. It becomes a kind of theater, a theater in which the residue is the work of art.

Kramer

The whole Pollock phenomenon is a kind of symptomatic one in that his position is based on a certain idea of art history, an idea of history that the museum, collecting, criticism, art market are all geared to, and that is what one might call the heroism of the big breakthrough. For myself, what was most apparent in the Pollock retrospective was at what a rather mediocre level his work had developed, except for a very short period around 1947, '48, '49, when he did his one, I think, rather small, original thing, which was the drip paintings, the allover drip paintings, which, as far as I can see, were his only claim to innovation.

Pollock was a very intense personality, but he wasn't a great artist. His work, like the work of all the New York School, is based on a kind of . . . well, to put it inelegantly, a kind of mopping-up operation of the School of Paris. It puts together certain remnants of Cubism, Surrealism, other developments of the School of Paris, and attempts to charge them with another kind of energy, which, in turn, requires a larger format and a bigger gesture, because something's being drawn to an end. I see the whole Abstract Expressionist phenomenon, and Pollock in particular, as a kind of last gasp of European modernism.

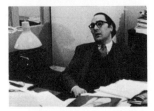

Clement Greenberg

Hilton's objection to Pollock comes out of an artistically incorrect reaction, but a sociologically correct one. Pollock is still taken for this example of far-outism. The people who admire him most on the New York scene today don't take him as a painter. They take him as an example of an artist in the line of Duchamp, someone who knocked you flat with his arbitrariness. Pollock is revolving in his grave, I'm sure, because he was a serious painter in something quite other than Duchamp's tradition.

His fame now on the art scene—the art scene is a special phenomenon—rests on the fact that he's thought to be the next one, or one of the next ones, after Duchamp to break with aesthetics, with good and bad, and to have made things arbitrarily and placed them in the context of art. This is the opposite of the truth. Pollock painted good pictures and he painted bad pictures, and he was aware of the difference. Like any other artist, he couldn't always tell for himself, but he would edit his paintings. He'd get dissatisfied with them, and there are differences in quality.

I'd place Pollock along with Hofmann and Morris Louis in this country among the very greatest painters of this generation. I actually don't think there was anyone in the same generation in Europe quite to match them.

Pollock didn't like Hofmann's paintings. He couldn't make them out. He didn't take the trouble to. And Hofmann didn't like Pollock's allover paintings, nor could most of Pollock's artist friends make head or tail out of them, the things he did from 1947 to '50. But Pollock's paintings live or die in the same context as Rembrandt's or Titian's or Velázquez's or Goya's or David's or . . . or Manet's or Rubens's or Michelangelo's paintings. There's no interruption, there's no mutation here. Pollock asked to be tested by the same eye that could see how good Raphael was when he was good or Piero when he was good.

Hess

One of the big problems of American art is that it is American. I mean, what is American? Is American being the most modern Westerner, that means, European, or is it something else in America? This has been part of the crisis of American art. How can you be an artist and not a hick, not a provincial, but still American? After all, you are here. Artists like de Kooning and Newman saw this with immense sophistication and moved into what I would call a cosmopolitan plane. Other artists like Still, using similar attacks on the problem, that is, painting from the inside

out, kept more within the American grain, kept more to
an old American idea of the West, of romantic beauty, the
Rocky Mountains, Walt Whitman, and therefore hewed
more closely to the traditional, let's say, provincial—I
don't mean that invidiously—traditional-provincial idiom.

Newman

I feel that I'm an American painter in the sense that this
is where I love to live, was born, and this is where I've
developed my ideas, and so on. At the same time, I hope
that my work transcends the issue of being an American. I
recognize that I am an American, because I am not
Czechoslovak, and my work was not painted in Czechoslo-
vakia or in Hungary or in India. But I hope that my work
can be seen and understood on a universal basis.

An American painting that is a reflection of the good,
old oaken bucket to me is folklore. It's nice perhaps to
know that it's possible for that to exist, but it really
doesn't interest me. But all these issues in the end,
whether it's American or whether it's painterly, are false
issues raised by aesthetes.

I expressed myself on this issue many, many years ago,
when at a conference of aesthetes and artists held in
Woodstock, I said to these aesthetes, "Even if you are
right and even if you can build an aesthetic analysis or an
aesthetic system that will explain art or painting or what-
ever it is, it's of no value really, because aesthetics is for
me like ornithology must be for the birds."

Motherwell

I suppose after Matisse, Mondrian was hit the hardest
with the criticism that his work was decorative or had to
be defended against being merely decoration. His was an
extremely thoughtful, reflective, and profound mind, in
my opinion, and his answer was, not philosophical, but
psychological: that the difference between that which is
decorative and that which is not is essentially a degree of
intensity of feeling. I don't think that contradicts but

rather is a corollary of my feeling that involves a value judgment, because the outlook that one has the deepest feelings about is what one values or finds evil.

When I used to teach at Hunter in the graduate school, the students were essentially school teachers and extremely ignorant, and I tried to cultivate them, among other things, in the history of twentieth-century art, and I had great difficulty with Mondrian, who literally looked like a bathroom floor to them—pure design—until I had the device of marking on the blackboard, on the left side "good" and on the right side "evil." I said to the class, "Let's play a game that Mondrian is not a decorator, but an ethical man regarding his work. What do you think he would regard in it as good, and what would he regard in it as evil?" And then this innocent, naive class really came up, in a different terminology, with very much the same things that Mondrian had argued himself: that he was for the universal against the particular, for the international versus the provincial, for the eternal versus the temporal, for an "art expression," to use my terminology, that was ultimately metaphysical and not immediate and transitory, and that he would have regarded as bad, or as evil, a high degree of particularity, the possibility, for example, of being able to determine the nationality of the painter, and so on. Once phrased that way, which is to say, once phrased ethically rather than aesthetically, they immediately got Mondrian.

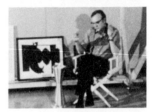
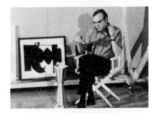
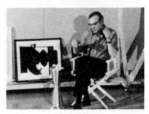
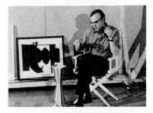

2. There was no audience in the beginning

Hess

De Kooning has always varied his work between abstract art and realist art, moving back and forth as if between two poles. Perhaps future historians will reexamine the work and not see any difference, because by then maybe abstract and realist won't be distinctions. It will be the same thing. But to us, and I think perhaps to him, there is a difference. His first pictures were abstractions, more or less geometric, more or less hard-edged, more or less bright colors. From there he moved into a series of men: poetic, tattered, romantic, poor looking men, tragic, haunted men. Certainly there's an idea of the Depression and of the breadlines and of the hoboes and the bums and of the tragedy of the unemployed in these pictures.

Shortly after his marriage, I believe, he painted his first women. A series of women in the late 1930s and early 1940s were unfinished and seemed to be searching for a way out of the European crisis or the crisis of art. He was

trying to find forms, and instead of finding them in abstractions, like the circle for a clock, he'd find them in an elbow or a shoulder and try to create his own elbow or own shoulder or his own eyes.

He moved from there into a series of abstractions. This was his really revolutionary move: he got rid of color. The abstractions were black and white. It was a series that lasted about three years, and when they were shown in 1948, de Kooning suddenly emerged as one of the most important artists on the scene. (By "the scene," I mean just a few artists downtown and their friends and a few dancers and poets and musicians and one or two critics. That was the scene.) To everyone's intense surprise, as soon as he had mastered these black and white pictures, he stopped them and began to paint women again. This time, using his newly found style and his, I guess, new confidence, he created by 1953 a series of figure paintings that would profoundly affect the next fifteen years.

Greenberg has said, it is rumored, "You can't paint a face." And de Kooning said, "That's right, and you can't *not* paint a face." The question is: How much liberty does an artist have to paint? If he has to invent every form for himself, he is like a man in one of de Kooning's anecdotes who works twenty years on this marvelous invention and comes up with the harpsichord, which is a great thing to do but doesn't advance the cause of music. If he looks and sees what art is around him and is aware of it, then he can, not build on that, but move in his own way and not get trapped in there. In other words, an artist can be trapped in what he doesn't know.

de Kooning

Giacometti was known for being a Surrealist sculptor, and he felt a need to make a statue again—I remember he wrote a letter, a kind of open letter to a magazine—and he thought it would be not too difficult. He would make some drawings, and he would make a piece of sculpture in that sense.

He had a model, and he couldn't get anyplace. It really became an enigma to him. He knew that the eyes were upstairs, high up, and the feet were down, and yet he could only make her stand straight. He worked for years and years and years. Then he started making very small, little sculptures, but he knew it wasn't a statue in the sense of a piece of sculpture. So it took him all those years to make those long figures: he said he wanted to take the fat off sculpture, as if it were far away. He had the idea that it was somebody who was walking maybe in the Place de la Concorde far away.

I didn't want to get that particular effect. I just wanted to make it easy for myself to put something right in the center of the canvas, like it had two eyes, a nose and mouth and arms and feet. And I had a terrific struggle with it. To tell you the truth, they scare me now. You know, they call me all kinds of names, but it had nothing to do with that: I wasn't antifemale or anything like that.

Hess

The question for any artist is how to start a picture. As a matter of fact, Dalí had an idea once of having a whole exhibition of paintings of blank canvases the great artists have left in their studios. He said it would be the most beautiful show in the world: Velázquez, just a plain, white picture, and Vermeer.

No artist wants to make that first move. That's the great inhibiting thing. De Kooning said that sometimes he used to just look at his thumb, just draw the line of his thumb. Sometimes he would write a word, like *art* or *rat*, on the picture and then make a still life or abstraction out of it.

In painting he also wanted this dumb, neutral space, especially in the women. He found that he could put a mouth into the picture; the mouth, I guess, was the area that bugged him. He'd just cut it out of a newspaper ad: this was a "Lucky Strike—be kind to your T zone," or maybe it was Camel. It was a woman's mouth pasted on

the picture [Study for *Woman I*, 1950], and that was the area around which—let's say, that was the eye of the hurricane—the calm in the center around which he could work and to which he could refer. Later, when he was painting the great *Woman I* [1950–52], he made himself a woman's mask, which he put on the picture and then painted around it. He kept changing the mask as the painting changed. And there's a kind of dialectical tension between this bit of reality and the art around it.

de Kooning

When I was working on those women, I had a lot of mouths out of magazines, and I noticed that when I had something, a photographic image like a mouth, it gave me a point of reference. It was something to hold on to. I also felt that everything ought to have a mouth. I mean, I think that was very funny. I think a mouth is a very funny thing because you do everything with it. With your ear you only hear. With your eye . . . you don't put spinach in your eye. It seems to me a mouth is a very strange thing. You eat, you whistle, you sing—some people are fabulous singers, like the Beatles or a great opera singer—and you talk with it. Of course, a woman's mouth is very appealing. I guess not all women's mouths. It ought to be appealing.

I pasted it onto the canvas. It was a shock. Then I knew where I had to go, more or less. It's interesting, though, that I could only do it with a woman. I guess it's because I'm not a woman. I couldn't do it with a man. Like the Japanese, they make those scowling . . . I couldn't do that. It became funny.

Actually they always call them women, but there are a lot of men in the paintings. Now, I have to make clear: I'm always late with the titles, and then I become known as a woman painter, but I can show you a lot of photographs, reproductions of paintings, which were not women at all; they were men. There isn't so much difference when you paint between a man and a woman.

I began with women, because it's like a tradition, like

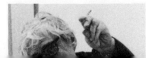

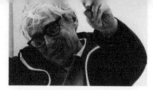

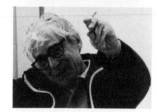

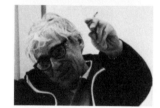

the Venus, like Olympia, like Manet made *Olympia* [1863].
Two winters ago I was for the first time in Paris, and I
went—I don't know where I was, I went so many places
—and I saw a little Cézanne, and I admired it so much. It
was hanging very high, and I couldn't really see it. I was
just taken with this painting. I thought he did it when he
was an old fool. It's Olympia, a little female on the bed,
on a high bed, and there's a slave girl holding something,
a robe or something. Then there's this older guy sitting on
the bottom looking at her, and his hat is in back of him.
There's a table and some things that make a room. I was so
fascinated, because there was no way of knowing that that
was a table. It's just a point of reference; it must be a table.
He was sitting on a couch, and his hat looked really more
like a turned-around flower pot. It really didn't look like a
high hat, the proportion, the shape. Those things fasci-
nate me very much. By luck, maybe it becomes a shoe. Or
a hand. It's kind of a mystery why. Then I thought he must
have painted this when he was a very old man. Just lately I
looked at a reproduction, and it wasn't true at all: he was
thirty-three years old when he painted that.

I'm an eclectic artist. I'm very much like that myself.
There seems to be no time element, no period, in paint-
ing for me. Like last summer I was in Italy and roamed
around places, and those early Christian-Roman wall
paintings, they just threw me for a loop. Particularly if a
brushstroke does it—I like painting with a brush.

I have all kinds of brushes. A lot of them are house
painter's brushes, and when I make those large landscape
pictures—so-called landscapes—I work with very wet
brushes, the kind of brushes you use when you paint a
ceiling: it drips all over you. They're made out of a fiber
and very little hair. I put them in boiling water until they
get kind of rubbery. Then they hold the paint, and it gives
me great comfort to paint with them.

Now, I find difficulty . . . I have to sometimes walk all
the way downtown and find some leftover brushes. In the

Depression period, I could get a lot of brushes like that. Other brushes I have made up by Grumbacher. I have them in three sizes—big ones and little ones—which have a certain awkwardness, which I get used to, which I like.

Emile de Antonio

How do you mix your colors?

de Kooning

Well, I found I had great difficulty with the earth colors, because they dry up much faster than the mineral colors. So I made up my own set of certain tones that would be equivalent to, say, yellow ocher, umber. I'm not doing this for any tradition, just because it was done before. It has nothing to do with that.

I make them up from mineral colors. I have charts here, and I make them out of full tubes of paint so that I can always make them again, with the slight difference, of course, that the batches of colors from the companies probably change; they're never the same. I don't think that artists have such good eyes to see the difference. I mean, the physicist would know more about it. One cadmium is slightly different, the molecular structure is slightly different, but I don't know anything about it. To me paint is just paint. It comes out of the tube, and I don't worry about it.

I'm very much influenced by the idea of water. You know, we are all surrounded here in this neighborhood by water; so I go on the bike and look at the water. Fishermen do it, too; they stand, and they very seldom catch a fish, but they like to reflect. So I have some double pun: reflecting upon the reflection. I try to get the light of this water. And it helped me enormously, because I already started doing it in New York, coming here often.

I felt in New York that I was using colors just

tically: yellow, blue, black, white. I had no way of getting hold of the tone of the light of a painting, or rather of a different kind of light than Mondrian would have. In a way, he was more of a naturalist, in the sense that he wanted to get absolute red and absolute black, white; he probably didn't even give it those names. When he made something it was never at the expense of something else. You know, each area—it's kind of a funny word, *area*—but each part of the painting was never at the expense of some other part of the painting. Something wasn't very small, because something else was very large.

Hess

De Kooning's problem is he wants the painting to seem fresh and painted "all of a piece," as he says. In other words, the picture should look like a flower that has just blossomed. But he's the man who works at destruction as much as creation. He paints out, erases, destroys, scrapes, then goes back. The great *Woman I*, back in 1953, was the result of almost two years of painting on top of painting on top of painting.

One of the technical problems is to keep the paint fresh. If you leave it overnight, it will dry. So he evolved a system of putting a piece of newspaper on the paint overnight to keep the oil from oxidizing, then taking it off the next day and working again. He found that sometimes he didn't want to change that area at all: he liked it. Or he didn't like it. But whatever his decision, the ink had offset from the sheet of paper onto the paint surface. Then you had images of bathing beauties and type, and, of course, he recognized that—I think he recognizes everything; I think artists see everything in their pictures—he recognized the very poetic and very rough and actual (from the French meaning of the word *actuel*), like a newsreel image he was getting into his picture. And he left it there. Whether it will last through the ages or not, I don't know. It's printer's ink, and according to scholars, that will not be there forever.

de Kooning

When I used the newspapers in the paintings, it was just an accident. When I took it off, I saw the backprint of the papers, and I thought it was nice. That's about all. It had no social significance that way, like Rauschenberg used it or something.

Hess

There is an advertisement called "The Public Be Damned," which Huntington Hartford bought, and I think he put it in every newspaper that had any circulation. I think there were seven in the whole country. And he attacked de Kooning pretty much along the lines Ruskin attacked Whistler: a pot of paint flung in the public's face. De Kooning was offending one of Hartford's wives, I believe, who had just had a show run the same month de Kooning's women were shown. It was a very dramatic ad, and, of course, it proved the old p.r. theorem that it doesn't matter what they say as long as they spell your name right. De Kooning got tremendous coverage. It's sort of a private joke that this perhaps made him. Actually, I think he was made by the pressure of his own reputation building up among a widening circle of collectors and critics and museum directors.

de Kooning

Nobody paid much attention to us except Clem Greenberg. I think he was one of the first ones to pay attention. And so, I guess, everything started to happen here in New York.

Jules Olitski

I don't think one really knows what the experience of making a painting really is. At least, it seems impossible for me to recapture it, and I doubt that the experience of looking at a painting can be stated explicitly either. It's possible to say certain things about painting: you can

point at something, you can say this is going on; and I think one of the great qualities of someone like Clement Greenberg is that he has that ability. It seems a very simpleminded kind of ability, a very rare one nonetheless, to be able to point to the mechanism of what is going on in a painting.

de Kooning

Years ago, Gorky and I came into the Valentine Gallery; he was going to introduce us to Mr. Eilshemius, the old painter Eilshemius. He says (we already knew him anyway), he says, "This is Mr. de Kooning"; and then he was going to say, "This is Mr. Gorky," but before he could, Eilshemius said, "Yes, yes, I know. Mr. Tolstoy."

de Antonio

How old were you when you had your first one-man show?

de Kooning

Forty-four.

Newman

I had my first one-man show in 1950. I was forty-five years old. If you run down the list from a man like Hans Hofmann, who was very much older, to those of my own generation, we were either forty-two or forty-three or forty-five. The only young one really was Jackson Pollock, who, I think, in his first show was thirty or thirty-one. But somehow I never thought of Jackson as a young guy in that sense. There were a few younger people, like Stamos, who was sort of the only one in his twenties. We were all of us in our forties when we had our first shows.

I don't think the issue whether we were accepted or not accepted was ever even thought about very much, that is, I didn't. I think people were puzzled and in many cases very, very antagonistic.

Josef Albers

It took me fifty years to get my first painting into the Museum of Modern Art. And that was not bought by Alfred Barr; it was given to him. Otherwise I wouldn't be there either. But I'm there now with sixty graphic works, with my furniture, with my lettering, with my book design, and with all my other nonsense. They must have more than one hundred works by me. But not through Mr. Barr. Is that interesting?

Newman

In my own case, the antagonism was not only general but very specific, because the nature of my work in 1950 seemed to be a threat against certain styles, so that we had no general public. The only thing that we did have was the opportunity of seeing each other in shows, so to speak. There were just a few galleries: Peggy Guggenheim up until 1947, when she decided to leave (which was a very early year to leave), and between '47 and '52, you might say Betty Parsons, Charlie Egan, and to some extent Sam Kootz were the only places where any of us had an opportunity of presenting ourselves, of showing the work. It was not, in that sense, a true marketplace. It was not, in that sense, even a showing place. It was a very special situation. It was a primitive cultural situation.

de Kooning

Barr thought that American painting couldn't be abstract painting—it wasn't American. They were more favoring the Regionalists, you know, and I guess they were a little bit against us: I mean, not personally, but that probably we were not on the right track.

Robert Scull

Abstract Expressionism brought abstraction to its very limits, but when Abstract Expressionism was made, it was

for a private club; none of the Abstract Expressionists
ever expected to sell their work. It was not really made for
customers; it was made for a little club that was down on
Tenth Street, where Rothko knew de Kooning, and de
Kooning knew Franz Kline, and so forth. They didn't
expect to sell their pictures. There were no customers for
them, so they did what they damned pleased.

Greenberg

I appreciated Eighth Street only after I'd been to Paris
for the first time, just before the war, in the spring of '39. I
was rather surprised to find that the young painters I met
in Paris at that time—none of whom I remember (and
there weren't that many)—seemed to me to be far less
aware than, let's say, the half-dozen American painters I
knew at the time, whom I called "Eighth Street." Actually
most of them lived on East Ninth Street, but Hofmann's
school on Eighth at that time was a focus of social activity.
People like Gorky would come around for company, for
people to talk to.

Pavia

All the language and all the criticism in American art
came from the idea of the two-dimensional plane, the
push and the pull. All these were Hofmann's words he
gave to his students, and his students were everybody
we knew.

Greenberg

Hofmann had a great responsibility in the fact that he
kept, let's say, an artist like Matisse up in the forefront of
attention at a time when his stock was down—down in
Paris, too—kept him in the forefront of attention for
young painters. Also Hofmann had this sense of continu-
ity with the past that was very useful, even when you
didn't consciously know the past, the whole past was
there. I don't think Hofmann himself was appreciated at
that time. He wasn't showing his paintings.

I think he was one of the greatest painters, one of the two or three best that we produced in New York in the 1940s and '50s, and yet his friends didn't like his painting. At the same time they weren't aware how much Hofmann was giving them in other ways. There he was, the grand old man, and all that. Everybody liked him and so forth, but it was all perfunctory.

Lee, Leonore Krasner, who later became Pollock's wife, was one of Hofmann's star students, and Pollock got a lot from Hofmann through Lee. I think he got more than he realized from Hofmann's proximity. They lived next door to one another on East Eighth Street in the early 1940s, and there the old man was.

Now, Hofmann wasn't as explicitly intelligent about art as he was supposed to be. He was a much better painter than he was a teacher. I didn't recognize that until the early 1950s and then all through the '50s. I think Hans got into high gear sometime around '54, '53, though he painted some great pictures in '42, '43, anticipations of Pollock, Pollock's drip method, but great in their own right, and anticipations of Still, whose name he hadn't heard at that time. He got into real high, steady high gear in the early 1950s.

Motherwell

My first show was under the most ideal circumstances, which was Peggy Guggenheim's gallery, called Art of This Century, which was on Fifty-seventh Street. It was a U-shaped gallery. As you entered the first leg of the U, so to speak, that side contained her permanent collection of modern, abstract art, Cubist works, Mondrians, Mirós, one of the most beautiful white Picassos of the 1930s that I've ever seen. The center of the U was given to whatever the current exhibition was. In the other side of the U was a tunnel, quite dark, designed by Kiesler, that contained her permanent collection of Surrealist paintings. Anybody who showed in the center of the U was surrounded by some of the most beautiful works of the twentieth

century, but hung in a completely unpretentious way.

All the abstract paintings had their frames taken off, which was unprecedented then, with simply stainless steel around the edges, and were hung on poles on universal joints, so that you could actually take hold of a Mondrian and turn it, swivel it into the light and so on, and really use it with the same familiarity that one does a library rather than standing as one does in a museum at a distance, awestruck before this altar. It was a very intimate, humane place of the first caliber.

Peggy was then surrounded by the Surrealists and also by abstract painters—Mondrian and Léger and so on—was then married to or was about to marry Max Ernst, was very taken by Duchamp's advice. Part of the rationale of Surrealism was that it would succeed in terms of its own intent if it developed young artists. Part of its pantheon of heroes was Rimbaud, was the early de Chirico, the early Dalí, and so on. It was a circumstance in which they were literally on the prowl for young painters, and what could be nicer if you were a young painter and one of them. I had my . . . Pollock was the first young American the previous season, which may have been the first season, followed by me, and, I think, during that season, Joseph Cornell. Then in subsequent seasons—my chronology is not exact; it's a long time ago—there was Clyfford Still and Mark Rothko. Rothko, with whom I became very close friends, I first met while he was hanging his show there. Clyfford Still I first met there, and Gorky. Not only did she first show properly or, in some cases, for the first time a brilliant generation of Americans, she also had first shows in America of such things as Giacometti's early sculpture, I think, of Arp's reliefs (though I'm not certain), and the thing that had a decisive influence on my own development, a collage show. She also every spring had a Spring Salon in which only young artists exhibited, and all of us exhibited in the salons.

She also made it extremely clear that she was a born expatriate, that the instant the war was over, we would be

on our own, and she would go back to Europe. And the instant the war was over, she did and left us all in the hands of other dealers. But that moment was extremely beautiful.

The painting *The Homely Protestant* [1948] was the result of all kinds of revisions. It's what's left over after revising and revising and revising. There was always meant to be a figure in it. There has been such interest in my Elegies to the Spanish Republic and collages and some of the abstract pictures that it tends to be forgotten that I was involved in a very abstract, but nevertheless really figurative painting. I was very puzzled by this figure, and it was then to be in an exhibition, and I was given the form to fill out with a place for the title, and I thought, "What shall I call it?" And because I was puzzled by the picture, I couldn't think of a title. (I usually title pictures after the fact.) In my difficulty in finding a title for the picture, in my despair of finding the title . . . because I think titles are important; I like titles that lead into the picture and in that sense try to make them either very accurate or, if I can't, make them not misleading. In this particular picture, which puzzled me, I wanted an accurate title, could not find one, and then I remembered the Surrealist device, which I'd never used before, of taking a book—and it had to be a favorite book, so I took Joyce—and opening it at random. Without looking at it, I put my finger on a page, and where my finger rested, it said, "The homely Protestant," and I thought, "Of course. The picture is *The Homely Protestant*," which is to say, it is myself. And I called it that.

de Antonio

Why do your paintings have political titles, like *Pancho Villa, Dead and Alive* [1943] and a whole series of Elegies to the Spanish Republic?

Motherwell

Well, after all, I was a child of the Depression. It would

take a very insensitive person not to develop a social consciousness during that period, particularly if one was an artist or an intellectual or especially if one were both. I also actually began painting in Mexico and was living with a Mexican actress whose uncle had been one of Pancho Villa's generals. Her family had been in exile in Southern California. I became very interested in the revolution down there.

Certainly to my generation before the Second World War, the great divide was the Spanish Civil War. In the same way that it would be very difficult now to find an intelligent youngster who didn't have very strong feelings about Vietnam, it would have been very difficult then to have found a creative person who didn't have very strong feelings about the civil war, which also at the time we oversimplified. It seemed a very clear-cut case between liberal democracy and fascism, and Spain's first, and perhaps last, chance to enter modern civilization.

Newman

The problem of giving work titles is a complicated and a personal problem. If you don't give the work titles and you give them numbers, you are in effect giving them titles, too; what you are saying is that your paintings are objects which you are numbering. Critics will say you need to make titles for identification and so forth. There are these practical things, but that is no issue.

For me, in the end, it was important that I should. In the beginning I suppose I was vague about titles—they did not seem that important to me—but I realized that the issue was an important one for me, because the title could act as a metaphor to identify the emotional content or the emotional complex that I was in when I was doing the painting. Since I was not painting anything that I was looking at in relation to the painting, there was nothing really to scrutinize—there was the painting itself that had its subject matter, had its content, which I hoped had an

effect on me and therefore would have an effect on anybody else who saw the painting—that I in some way characterized the emotional content at least that I had had when I worked at it. So my titles, I think I try in my titles anyway to evoke the meaning that the painting had when I was painting it.

de Antonio

Why do we seem to get involved with bigger and bigger paintings with the American artist of today?

Motherwell

I think there are lots of reasons for that. The scale of America is different. I don't mean that one goes out and looks at the desert. Most painters live in cities. I would say that most American painters work in what were once small factories, whereas European artists work either in apartments or studios that were designed in terms of the scale of easel painting.

There's no doubt, too, that there's a different experience in a large picture, but I think it has more to do with—I hesitate to use the word, but I can't think of any other—a *heroic* impulse as compared with the intimacy of a French painting, and also with the social fact that there was no audience in the beginning. Anybody who was interested in modern art in the early 1940s was interested in European art, so that American artists who weren't overwhelmed by European art had a virgin, uninhabited territory and, I think, might very well have, since there was no tight social context in which the work was being made, felt very free to shoot the works, so to speak.

I think in the course of the years, that original heroic impulse has been transformed into less admirable sentiments on occasion, because obviously a large picture of equal quality in modern circumstances which you see in galleries or museums is more apt to attract attention than would a smaller picture. Nevertheless, certainly the origi-

nal impulse was not that, because the museum world and the gallery world really greatly resisted painters showing big pictures or making them.

Hess

Almost since the New York painters have been showing, their exhibitions have been characterized by big paintings, paintings too big to be sold. There's almost a perverse streak in this. I remember Adolph Gottlieb was going to have an exhibition at the Marlborough Gallery. He went to the gallery, and the owner showed him the beautiful space, and the ceilings were eleven feet high; so Gottlieb went home and painted fourteen-foot-high pictures, many pictures that could not be shown. There's a kind of attack on the public in these large paintings by the Abstract Expressionists. They were showing an ambition which could not enter the marketplace.

Later, of course, a younger artist picked up the idea; and situations have changed, lobbies have been built. . . . Now it turns out by some crazy paradox that big pictures can move. But there was something very perverse about the large paintings—and very typical of the movement. Also, men like Rothko and Pollock discovered the big picture was a more intimate mode than the small one; it moved around the spectator and embraced him at the sides and permitted the artist a much more one-to-one relationship with the spectator, again breaking through the stereotype and getting directly to the people.

Newman

I recall my first painting, that is, where I felt that I had moved into an area for myself that was completely me, I painted on my birthday in 1948. It's a small red painting, and I put a piece of tape in the middle, and I put my so-called "zip." Actually it's not a stripe. Now, the thing that I would like to say about that is that I did not decide, either in '48 or '47 or '46 or whatever it was, I'm going to paint stripes. I did not make an arbitrary, abstract decision.

Now, I suppose I thought of them as streaks of light. I really don't know how I actually thought of them exactly. The reason that I say this, when I painted this painting, which I call *Onement*, my first *Onement*, so to speak, I stayed with that painting about eight, nine months, wondering to myself what had I done. What was it? I realize that up until then, whenever I used that sort of a, you might say, attitude—I don't call it a device—that I was constantly building things around it. I was filling the canvas in order to make that thing very, very viable. And in that sense I was emptying the canvas by assuming the thing empty, and suddenly in this particular painting, *Onement*, I realized that I had filled the surface. It was full, and from then on those other things looked to me atmospheric. In that painting I got rid of atmosphere, you might say. I felt that for the first time for myself there was no picture making. That stroke made the thing come to life for me.

Hess

Since around 1920, Europe had schools of what was called geometric painting characterized by a search for harmonies, balances, and symmetries by the artists, the most famous of whom was Mondrian. This is based on the platonic idea that there is a beauty in geometry. Newman wants to make it very clear that it has nothing whatsoever to do with an external idea of beauty. Geometry implies that there is a truth someplace outside the artist and outside the arts, like Plato's geometry and Euclid's geometry. Newman works inside and looks inside for his forms. His attack on geometry . . . I think he has a number of titles: there's one called *The Euclidian Abyss* [1946–47], there's one called *Pagan Void* [1946], both of which refer to his attack on geometric art.

Newman

I feel that my zip does not divide my paintings. I feel it does the exact opposite. It does not cut the format in half

or in whatever parts, but it does the exact opposite: it unites the thing. It creates a totality, and in this regard I feel very, very separate, let's say, from other mental views, the so-called stripes.

Motherwell

Chance is not a primary idea with me and is very different from automatism, though it's an element in automatism. Automatism is essentially what psychoanalysis would call free association, and it can be evident in the Surrealists either as plastic free association or literally free association or a combination of them both. Nevertheless it is true that the Open series I discovered entirely by chance. One day I put a small, vertical canvas against an unpainted one, a large, vertical canvas that had a yellow ocher ground painted on it and on which I intended ultimately to put an image. One day walking through the studio, observing the smaller canvas against the larger one, I thought, "What a beautiful proportion," and, without a second thought, picked up a piece of charcoal and outlined it on the larger canvas and then again didn't think anything about it. But looking at it over the months, I liked it, and several people who saw it liked it, and one day I took it home, which is to say, I took it to my house from my outside studio in order to see it every day. One day it occurred to me, the more I grew to like it and thought that I would make some more and investigate its character and why I liked it, that it might have more possibilities if I turned it the other way up. The original was a door, so the door became a window. I ultimately decided on the window rather than the door, not that either in that particular picture was more appealing, but it seemed to me that there were more possibilities of —what shall I say?—of moving toward the sky rather than moving toward the ground.

When you're making three lines function as a whole, huge picture, at the moment it often seems like an absurd

enterprise. And yet I've had, from time to time, people say, "What I like about your painting is its mastery," as though I were Titian in total control of all the elements, whereas when I'm doing it, I feel much more like I'm facing a shark in very deep waters, I mean, really very frightening waters. I think a great deal of one's life is mobilizing the psychic strength to endure that, and yet one never endures it enough.

The other thing I'm really committed to is, as I understand it, very intense feeling, and without that it is decoration. Maybe it's more clear in someone like Pollock, who now in many ways seems like a very lyrical artist; one has no conception, looking at the finished work, of madness and risk and nerve, of being on the edge of the abyss, which it seems to oneself when one is actually making them. I know Rothko regarded painting as a form of torture, and I think all of my generation or most of my generation to a great extent experienced it as such. And in that sense, it was a very un-French experience, unless, as I'm now inclined to believe, the French with all their—or the Parisians, I should say—with all their beauty of surface were pretty tormented themselves.

In the next ten or fifteen years, whatever I have left, there are a lot of things I want to say in pictures in terms of ranges of feelings, and using a relatively simple image allows me to move more quickly from tone to tone and from investigation to investigation. But also I have in the back of my mind to make some really huge Spanish Elegies some day. Once by chance I saw slides of my Elegies with works by other modern artists which were actually much larger but on the screen looked identical, and I realized that there was something in the elegy idea that really cried out for huge expression, not just to be huge but that it had sufficient tragic quality that a very large format would be appropriate.

The Open paintings, among other things, are involved in scale, which is to say, I call them *open* primarily in the

sense of an open door, but a very specific door—or I should say, window—that I wanted to walk through and contemplate from every possible aspect. One of the things involved is scale. I've investigated the small scale and the large scale. I've made some as small as five by seven inches. The largest, so far, is eighteen by twenty feet. One of these days I want to hire a scenic studio and make some really huge ones.

de Antonio

You don't use the big canvas as much as many of the other people of the Abstract Expressionist movement. Why don't you?

de Kooning

I couldn't. My paintings are too complicated. I'd be working on them forever after. I don't use the large-size canvas because it's too difficult for me to get out of it.

Kramer

Paintings are bigger now, because they deal with fewer visual ideas. There's a kind of insidious logic in it that the smaller the visual vocabulary, the larger the picture has to be in order to sustain itself as a visual phenomenon. So that a Barnett Newman that was the size of a Paul Klee would simply be laughed out of court. I mean, it would, in my opinion, reduce Newman's ideas to their proper size and he would be seen as the distinctly minor and somewhat comic figure that he [was].

Newman

I was concerned constantly in doing a painting that would move in its totality as you see it. You look at it and you see it. And if you don't, there's nothing to walk into. It's not a window leading you into a situation where you walk through some either interior or exterior world from which you then come to a conclusion. The beginning and the end are there at once. Otherwise, a painter is a kind of

choreographer of space, and he creates a kind of dance of elements, and it becomes a narrative art instead of a visual art. When you see a person for the first time, you have an immediate impact. You don't have to really start looking at details. It's a total reaction in which the entire personality of a person and your own personality make contact. To my mind that's almost a metaphysical event. If you have to stand there examining the eyelashes and all that sort of thing, it becomes a cosmetic situation in which you remove yourself from the experience.

I think, in a sense, my painting removes the observer. At the same time I'm not too happy about those writers who always talk about some of my large paintings as environmental, in which the observer becomes part of the painting. I like to think of the person becoming part of the painting in terms of its meaning, because in the end I feel that most of my paintings are hostile to the existing environment.

Leo Castelli

Back in the nineteenth century, people like Delacroix used to paint immense paintings for museums and for churches. Michelangelo did that, too, in the Sistine Chapel. It depends so much on what a painter wants to achieve. There really is no special reason, I would say. Of course, it seems to be a rather impractical thing to do now, since apartments in New York are so small, have low ceilings.

There is also a little bit of defiance in there. Painters want to do it their own way, and if they are not salable, then, well, too bad.

Newman

There's no question that my work and the work of the men I respect took a revolutionary position, you might say, against the bourgeois notion of what a painting is as an object, aside from what it is as a statement, because in the end you couldn't even contain it in an ordinary bourgeois home.

I think there's a problem now that is to some extent misunderstood, and this is that if you simply make a large superpainting, bigger than a normal bourgeois home, that fills a whole wall, that you have by that simple fact eliminated the bourgeois life. I'm not so certain. I'm not so sure that a painting, just because it's large and by itself eliminates the sense of a painting over a fireplace and fills the modern wall in somebody's home surrounded by Mies van der Rohe chairs, is any less bourgeois. There's more to the problem, it seems to me, more to the issue than any old-fashioned idea of what an easel painting is. A painting can be bigger than anything that can go on an easel and still be, in my opinion, an easel painting.

In the end, size doesn't count. Whether the easel painting is small or large, it's not the issue. Size doesn't count. It's scale that counts. It's human scale that counts, and the only way you can achieve human scale is by content.

3. Modernism is a group research project

Helen Frankenthaler

The first time I met Pollock I was very young and very shy. I knew his name and I esteemed him and I knew he was an important painter. It was a social introduction. The next time I saw him was at his opening at Betty Parsons, and that show influenced me enormously. I was very struck by it and went to it over and over again, just sort of bathed in it and learned a lot. Then I used to go out and visit him in The Springs. By then I knew how he painted, how he moved, what his shoulder signature was about; and there were a number of things that influenced me only because I was ready for it in a given context.

In other words, having looked hard at Kandinsky, Gorky, and Cubism, I was then ready for the next progressive step, which, fortunately, out of choice and circumstance was Pollock, so that there's a logical progression. It wasn't as if Pollock appeared out of the blue to influence me, but I was ready to be influenced by that next

dimension. What I did learn from him, or—well, yes —take from him, was the idea of working directly on the floor. At the time I didn't intellectualize it, but it almost physically appealed to me. I did not want a small gesture, standing at the easel with a sable brush, and Cubism, which can be very detailed, minute, and fine, has that essence at times of the easel and the sable brush. I literally wanted to break free, put it on the floor, and throw paint around; and this was very appealing to me.

Albers

I have taught my students not to apply rules or mechanical ways of seeing. Traditionally art is to create and not to revive. To revive: leave that to the historians, who are looking backward.

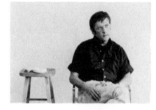

Kenneth Noland

At Black Mountain [College] we were already involved in abstract art, you know, out of the Bauhaus mostly. When Abstract Expressionism came along, it came along more directly out of Cubism. We had been involved in geometric abstraction, pure abstraction with no subject matter other than the making of paintings.

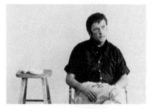

I was more interested in the making aspect of Abstract Expressionism than I was in the subject matter. I mean by that the fact that the artists were handling the materials in a physical way, the fact that they were making painting.

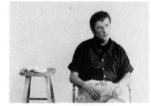

In order to make art, you have to have some way to begin to organize the making of it. Drawing was being passed down as a way of planning to make art. Artists were drawing as a way to set up the subject matter or the form of art. Everybody was assuming that the way you went about making art was to start out with drawing; that had been in the Western tradition. Artists would take pencil and a piece of paper and make sketches or would make plans about how pictures were going to be organized, to imagine what the result was going to be. Most artists

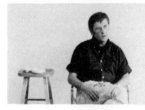

wouldn't just go out and get materials and start messing around with them and find some way out of handling material and techniques to have the result of what they were making come out of that. They were using drawing in order to structure where they put color, shapes, scale, depths, and so on.

Pollock meant more to me than any of the other Abstract Expressionists. Then, I think Clyfford Still I admired, too, because of that handling aspect of the materials that both he and Pollock used. They didn't suppress the tactile quality, the handling of materials to any other picture image. You never lost sight of the touch of the making in their work, whereas, say, even though de Kooning's work is very tactile, it is gestural, and gesture, after all, is just a kind of line; it's a kind of drawing.

Frankenthaler

For me learning Cubism was the greatest freedom and exercise, and that came through Paul Feeley at Bennington, where we would tack up on the wall Cubist pictures of 1910, '12, '14, mostly by Braque, Picasso, and Léger. We would see why they were any good, how they worked, what they did in space: why a guitar up here related to or didn't relate to the symbol of a bass note down there, and how things pushed each other around in an ambiguous space that was really one flat piece of paper or canvas. The whole drama is that it's flat, but that I can make it, if I do it right, play around so that because of the color and the shape things go back miles or come forward yards. That's what one can learn from Cubism. I think Hofmann called this "push and pull." I think everybody involved in the development of abstract painting has another phrase for it. For me any picture that really works, whether it is a Pollock, a Hofmann, or one of mine, or practically anybody's, once I know I like it and it's beautiful, I think, "Why is it better than that or what makes it the same?" It does have that play of space, and that for me comes out of what Cubism is about.

Leider

The conventions of easel painting call for a picture box; the essence of easel painting was that it cut a hole in the wall and made a three-dimensional scene. Clem once said you started making flat pictures, abstract pictures that had no use for depth, had no use for sculptural shapes and dark and light contrasts, then you effectively got rid of the conventions of easel painting. The other thing was the ending of his essay; that was really smart. There he said that what need painters like Pollock seem to be fulfilling is the need for breaking down hierarchical distinctions, and he noted—and made a point of noting —that this had enormous decorative implications. He named a whole bunch of artists, a lot of whom have dropped out of the picture, but Jackson Pollock in particular, and he talked about the even texture and the lack of any need for fictive depth in the picture, and this effectively, as far as he was concerned, eliminated the convention . . . you didn't need easel painting to do this.

The convention of nonorder, nonhierarchical kind of art, leads out of the easel picture into a three-dimensional object: [Carl] Andre's identical units, no relationships. You get an Andre pile of bricks, a length of bricks, no unit being subordinate to another as in any other kind of sculpture.

de Antonio

This was being done in music in 1912. In [Arnold] Schoenberg, every note, every one of the tones has exactly the same value as if it were a pile of bricks laid out.

Frankenthaler

I painted *Mountains and Sea* in October 1952. I had recently returned from a driving trip through Nova Scotia and Cape Breton and done a lot of watercolor landscapes at that time. I had a studio on Twenty-third Street, and that fall I guess I had ordered a lot of unsized, unprimed

cotton duck, which we all bought from a sailing supply place. I had already played with the idea of working on the floor, but I hadn't done any large pictures directly on the floor. After a summer of making small, careful, after-nature watercolors, I got into my place on Twenty-third Street and felt sort of "let it rip!" So I left the stuff on the floor, and I mixed paint in hardware store pails and coffee cans.

I was still either starting out with lines or somehow incorporating lines as a remnant of Cubism in my pictures. I first made the gesture of sort of blocking out the picture, but I didn't know what was about to happen. I made some lines, and, in fact, got rid of some of them. Then with landscape in mind, but at the same time having only a concern with the paint, the floor, and the moment . . . I mean, I wasn't thinking of this as an abstract landscape. I see it as a painting, and that was the whole point of the picture, not what it came from or what the association was, but that square footage.

I poured the paint and used relatively few brushstrokes. I didn't want the sign of the brush or how the picture was made to appear. When I stopped painting, I knew the picture was finished. (Now, that sounds like a funny remark, but what I mean is, one can pause and continue or can pause and wonder whether or not to go on.)

Since the canvas was on the floor, and the paint was of a creamy liquid consistency, it formed pools and bled into the canvas and onto the floor. (In fact, many of my best pictures are on the floor.) Many people, in retrospect, like to feel that this at that moment was something planned, discovered. I see it as something that I had to do that naturally evolved. I didn't finish the picture and think, "Something terrific has happened." I didn't think that at all. I thought I had made a picture that looked like no other picture I had ever made, and I felt I should leave it and take it from there.

At that time I was sharing the Twenty-third Street studio with Friedel Dzubas. We talked a lot about painting

and looked at each other's pictures. In many ways we supported each other. I called him over and said, "What do you think of this?" because we did that all the time. We would either say, "I don't get it," or "why don't you add a little more blue up there?" or "terrific!" or whatever. He liked it. That day we were having a drink with Clem, and Clem in his style, which is very encouraging since he has such a good eye, said, "Terrific," "do more of them," "keep going," you know, "you're red hot." And so I did.

All the circumstances before it were of crucial importance, but all relative to the things one has to do and one's original identity. I mean, there is good luck and there is bad luck and there is the right moment and the right material and the right eye and the right street, but you are carrying yourself and your head and your heart and your hand around, and you do the best you are. Anyway, I did many pictures that were spawned from that.

I feel that one takes advantage, in painting, of chance or accident. In other words, you direct something to happen that surprises you, and then you use it, exploit it, cancel it, wreck it, embroider upon it, whatever, but there it is, and you have the wherewithal, intelligence, and energy to recognize it and do something with it. There are many accidents that are nothing but accidents—and forget it. But there are some that were brought about only because you are the person you are.

Accidents don't just happen by mistake or by magic, but that one brings everything one is to bear to allow for a puzzle or a surprise. Given the ingredients of certain materials, certain intelligence, certain mood, certain light, certain hope, certain past, certain ambience, you can leave the door open to recognize how to use something that you've never seen or expected before. And that can be a kind of shape next to another shape or the fact that the color of mud has never been used as a color or that a line doesn't have to be a black mark that goes straight from here to here or, for many people, that forms of everything we do in art don't have to be the forms that we

assume they are. I mean, there is leeway for chance.

But, I think, there is often a lot of stupid confusion about "Oh, this just happened, so I left it in." I think that the recognition and censoring and, again, exploitation of what is called accident, or chance, is as intellectual and is as physical as a decision you might make in dipping a sable brush into vermilion.

Geldzahler

I think one of the ways to look at modernism is as a group research project, the way pure mathematics might be, so that the advances that are made in the field are advances that become available to everybody who's working in it. It's a dialogue, and what looks like it might be a misdirection, something that an artist is doing just for the hell of it, turns out, in fact, to be something that can be used by somebody else.

Helen Frankenthaler's work developed in its own way. Her influence was picked up, and the direction of the painting of the 1960s was changed, not so much by what Helen did herself as by the way other people saw what she was doing.

Clement Greenberg included the work of both Morris Louis and Kenneth Noland in a show that he did at the Kootz Gallery in the early 1950s. Clem was the first to see their potential. He invited them up to New York in 1953, I think it was, to Helen's studio to see a painting that she had just done called *Mountains and Sea*, a very, very beautiful painting, which was, in a sense, out of Pollock and out of Gorky. It also was one of the first stain pictures, one of the first large field pictures in which the stain technique was used, perhaps the first one. Louis and Noland saw the picture unrolled on the floor of her studio and went back to Washington, D.C., and worked together for a while, working at the implications of this kind of painting.

They were close friends for a while. Then they worked in a rather isolated way from each other. I think the fact

that they were in Washington rather than in New York perhaps freed them from some of the, not misconceptions, but the basic underlying premises of Abstract Expressionism. It was enough distance from the sophisticated center to allow them their freedom and close enough to allow them to make the occasional trip to see what their fellows were doing.

Noland

Morris and I were talking about art, and we found that we were interested in a lot of the same kinds of things, the same kind of art that was being produced. Pollock, of course, was the one that we talked about the most, and the one we were most interested in. We knew about Helen's work, and we felt that Helen had found a way of working, handling the materials, in the same sense that Pollock had, with a lot of that other aspect, drawing, being left in the work in a kind of arbitrary way. She handled the materials directly, and that was the reason we were interested in what she was doing.

Morris and I used to talk about what we called one-shot painting. I guess it had to do with the fact that if you were impressed with what you were doing, you only had to do it one time if you could get yourself together so that each thing that you did was just done that one time with no afterthoughts and it had to stand. It might relate a little bit to improvising in jazz.

A lot of terms have been invented that for the time being serve a kind of convenience for writing, but they don't define the art in any way. I don't really pay very much attention to most of them: color field, postpainterly abstraction. I think probably color-field painting, what is generally meant is that the painting is mostly generated by color rather than by, say, drawing or any other means.

Olitski

While I was teaching at Bennington, I had a seminar,

and I thought it would be interesting to have the students visit Ken Noland's studio in Shaftsbury, Vermont [in the spring of 1964]. So Ken was there and I was there and Tony Caro was teaching sculpture there, and my students just sat around on the floor. The way art students seem to be in the last few years, they didn't say a goddamned thing, no questions, no responses, nothing. So what happened was that Tony and Ken, myself, we began talking. And Tony said something about . . . I think it was about wanting to achieve a kind of materiality of sculpture. (I don't want to be held to this; I'm not sure I'm quoting exactly.) But I responded to this with what I would like to get: I said, "If I could just get a spray of color in the air and somehow it could stay there, that would be it." And everybody laughed, and I did, too. It seemed amusing.

You know, the way you say something, it's almost as if you have to open your mouth and talk to find out what you're about, like what's in your being. In any case, that night when I went to sleep, I went, "Well, yes, that would be the thing I would like to get." So this spray painting came out of that notion.

I don't know what color-field painting means. I think it was probably invented by some critic, which is okay, but I don't think the phrase means anything. Color-field painting? I mean, what is color? *Painting* has to do with a lot of things. Color is among the things it has to do with. It has to do with surface. It has to do with shape. It has to do with feelings which are more difficult to get at.

Geldzahler

Color field, curiously enough or perhaps not, became a viable way of painting at exactly the time that acrylic paint, the new plastic paint, came into being. It was as if the new paint demanded a new possibility in painting, and the painters arrived at it. Oil paint, which has a medium that is quite different, which isn't water based, always leaves a slick of oil, or puddle of oil, around the edge of the color. Acrylic paint stops at its own edge.

Color-field painting came in at the same time as the invention of this new kind of paint.

Another way of looking at it in American terms is that America has a very great tradition of watercolor painting, which has, I think, been underrated. Winslow Homer, Maurice Prendergast, John Singer Sargent, Charles Demuth, Georgia O'Keeffe: right through the last eighty or ninety years of American painting, watercolor has been one of our strongest media. In a sense you can think of this staining technique of paint on canvas as parallel to the way watercolor works on paper. So that stain painting or color-field painting or whatever you call it can be seen as an enlargement of watercolor technique, a particularly American development.

Frankenthaler

I changed to acrylics for a number of reasons. One, I was told that they dry faster, which they do, and that they retain their original color, which they do. I would say durability and light and the fact that one can use water instead of turpentine: all that makes it easier given the abstract image. In the way that sound echoes sense, the materials come along that are called for within the nature of the aesthetic. As painting needed less and less drying time, depth, and so forth, the materials came along that made that more obvious.

When I first started doing the stain paintings, I left large areas of canvas unpainted, I think, because the canvas itself acted as forcefully and as positively as paint or line or color. In other words, the very ground was part of the medium, so that instead of thinking of it as background or negative space or an empty spot, that area did not need paint because it had paint next to it. The thing was to decide where to leave it and where to fill it and where to say this doesn't need another line or another pail of colors. It's saying it in space.

A red-blue against the white of cotton duck or the beige of linen has the same play in space as the duck, or

that duck assumes as important a role as the red shape. Every square inch of that surface is equally important in depth, shallowness, and space. The plate that the apples are on is as important as the apples themselves. It isn't as if background meant the background is a curtain or a drape in front of which there is a table on which there is a plate on which there are apples. The apples are as important as the drape and the drape is as important as the legs of the table.

When abstract painting does not have illusion of depth, perspective, space, and when it does not have that ambiguity of playing in volume, then it becomes pure decoration. It becomes automatic, tiresome. It's sort of a motif. It's like wallpaper. If you just put drips down or circles or stripes or bleeds, that can become yard goods. But if you put that stripe with magic there against that particular background near that particular circle, and you are involved in a whole ambiguity and play in depth, knowing full well that it's all on that flat thing—I mean, you could just skate on it— that's what makes terrific painting.

Noland

I thought that being horizontal, just the nature of being horizontal, in a way was more abstract than being vertical, because, for instance, if you look at the ocean, we tend to see a field, and we don't see anything specific; if you just look at horizontals, you see a span. If you've got a sailboat or a boat on a bay or something like that, then you've got something specific, and you see an object or you see a thing. If everything is just horizontal, there's no place, there's nothing to focus your eye on, to fix visually. I think that if we see horizontally, we see flatter.

de Antonio

How do you make a painting?

Noland

I start with a roll of canvas and some paint. It's a matter

of getting those materials together, I'd almost say, more in a tactile sense, texture sense, than a drawing sense or diagram sense, that is, just how you handle the materials, how thin or how thick the paint is, what the weave of the canvas is. I roll the canvas out on the floor and staple it down, then tape off quantities of surface.

Sometimes I apply the paint with brushes, sometimes with sponges, sometimes with rollers . . . any way that I can get it on where the tactile result is compatible with the nature of the color I'm going to use there. One thing that people don't generally talk about is the fact that the experience of color is tactile. We talk about the relative coolness and warmness of color, or transparency or opacity, and really all those descriptive terms are tactile descriptions rather than to do with the redness of red.

When the color is first laid down, it doesn't have anything to do with the resulting size or shape really. Once you lay it down, you can choose by sight how to bring the total color into a certain quantity. . . . For instance, I could make that picture more square, and if I made it more square, then it would become denser and the color would have movement in it. If I extended it longer, you would have a faster kind of movement. You have a way of getting the color to take on a different degree of speed, translucence, transparency, opacity, density, even to the warmth or coolness for that matter.

I'm interested in the pulse of each color finding its place in relation to the pulses of other colors. It's like getting colors in accordance. There's no such thing as a bad color: it's just situated in some way that it's not all right or there's too much of it or there's too little of it. It's in the combinations. If you get that combination into a certain kind of focus, then that focus itself dictates the size and shape—or the size and shape will dictate a certain kind of focus—and will make any colors compatible.

de Antonio

Why do you paint large pictures?

Noland

Because there is no reason not to paint large pictures, I mean, any more than there's any reason to, say, paint any size or shape but pictures. It should just be that any size or shape should be available to make paintings out of. There's no use cutting off certain possibilities because of size or he[ight or length] or any other reason.

The quantity of color on the edges has to do with shaping the pictures. The pictures are roughly the size they're going to be, but it gives me this slight margin, adjusting the quantity of the color to the whole shape. Judgment comes in, and I think judgment's crucial. You do decide, and that has something with taste. Taste: we use it in the negative sense, but there's also best taste, you know, there's right taste. There's the real taste. There's Painting : a candid hist

Everybody should think, if you say you're intuitive, rather than intellectual about, say, painting, that this is somehow in the arts, actually all intuitive really is based on accumulated experience. you're probably more accurate than when you're trying to decide mentally, you're apt to guess more than if you know what you're about.

Frankenthaler

For me a picture that is beautiful or comes off or works looks as if it all happened or was made in one stroke at once. By that I mean that you don't have the feeling of how it was made, with what materials, with what thoughts, with what censoring apparatus. Now, I think all those things go into it: you use a certain medium, you stand back and think, you rework ideas, you rework the picture itself. But if you have that immediate hit . . . *éclair* . . . light. . . . Here is the thing: whether it's a Titian or a Picasso Cubist picture or a Pollock or a Noland, when you get the first "Wow!" then you can say, "Ah, how is it made? What

intellectualizing went into it? What kind of paint went into it? What kind of mood went into it? What has it come out of? Aesthetically, where is it going? How does it relate to the artist's other work?'' But I myself don't like to see the trail of a brushstroke, the drip of paint, the mark of the heel of the shoe. To me that's part of a kind of sentiment or cluing that has nothing to do with how a picture hits you.

4. Art comes from neither art nor life

Robert Rauschenberg

The Abstract Expressionists and myself, what we had in common was touch. I was never interested in their pessimism or editorializing. You have to have time to feel sorry for yourself if you're going to be a good Abstract Expressionist, and I think I always considered that a waste. What they did—and what I did that looks like Abstract Expressionism—is that with their grief and art passion and action painting, they let their brushstrokes show, so there was a sense of material about what they did.

Jasper Johns

The idea did come to me that I should have to mean what I did. Then, accompanying that was the idea that there was no reason to mean what other people did. So, if I could tell that I was doing what someone else was doing, then I would try not to do it, because it seemed to me that

de Kooning did his work perfectly beautifully and there was no reason for me to help him with it.

Rauschenberg

I was the "charlatan" of the art world. Then, when I had enough work amassed, I became a "satirist"—a tricky word—of the art world, then "fine artist, but who could live with it?" And now, "We like your old things better."

The black and the white paintings were done at the same time—this was '50, '51—because I meant neither. Everybody used remarks like "burned black," "nihilism," "destruction" (for the blacks), and "empty." None of those early things were about negation or nihilism. They were—I don't know—more like celebrating the abundance of color. It seemed to me there had to be a good reason. . . . Like what I learned from Albers: he said that you had to have a good reason to decide one color over another. In the exercises, seeing the clinical tricks that were involved in color, I met a lot of nice colors, but I couldn't justify with any idea what would be a better one or not.

Then I did all red. I picked arbitrarily the most difficult color that I could work with, and it was red, because red goes black very quickly. Then gradually it just opened up, and I found it got a little closer to yellow, which made orange, and then it went into what I call "pedestrian color," where you see a roomful of people and the room stays the same color, but the color is there whatever color it is. I tried to work with isolated detail as opposed to juxtaposing one against another. You know, you choose green to make the red look redder or red to make the green look greener.

Castelli

Nobody had understood Rauschenberg before. I had been wildly enthusiastic about his show a few years before at Egan's, the so-called red show, which was a fantastic event that nobody understood. He didn't sell a

single painting out of that show, except perhaps to friends who gave him $50 for paintings that would be worth now $40–50,000 so that he could go on and pay his rent.

Rauschenberg

At that time surplus paint fit my budget very well. It was like ten cents for a quart can downtown, because nobody knew what color it was. I would just go and buy a whole mass of paint, and the only organization, choice, or discipline was that I had to use some of all of it and I wouldn't buy any more paint until I'd used that up.

Castelli

I opened my gallery in February. It was the fifth of February, 1957. I'd like to describe to you the scene at that time. To begin with, I must say that it was a very modest affair on the fourth floor of this building where I still am; I lived also in that apartment. The gallery was in the back and just one office, and all the storage I had was a large, walk-in closet. Imagine! Now I have a warehouse with something like 7,500 square feet, and it's not sufficient (true, because I use it mostly for the exhibitions, so I'm to blame for that, for the lack of space).

Abstract Expressionism was the dominant movement then, and I really had no very clear ideas about what I was going to do. I had some European paintings that I had accumulated over the years, more as a collector than as a dealer up to that moment, and I sort of felt that American painting was much superior to European painting; it was clear to me much earlier, say, in the beginning 1950s, early '50s and even late '40s when Pollock appeared upon the scene.

What I wanted to demonstrate with my first show was that situation, which I had recognized much earlier than that. I had that idea, that feeling, already back in 1951, let's say, when together with Sidney Janis we organized a show where we had artists, American artists and their opposite numbers, as we thought, in Europe. And already

then, of course, it seemed quite evident that Franz Kline was a much better painter than [Pierre] Soulages, say, who was his opposite number. The only man that there is to play against the de Kooning *Woman* was [Jean] Dubuffet, curiously enough, and he has held his own. But all the rest were much weaker. There was Matta against Gorky, for example, although Gorky had been Matta to begin with; he is and was, as we knew, as I knew, and as people have come to realize now, a much better painter in time.

So I felt that in my first show I wanted to stress this idea that American painting was just as good as the European, the great Europeans. So I had a show which included Léger, Mondrian, Giacometti, Dubuffet, to mention just a few Europeans, plus Pollock, David Smith, and de Kooning. So that was, I think, something that I wanted to demonstrate for a long time, and nobody had done it.

Janis, for instance, never mixed, though he was handling Pollock, de Kooning, and all those people at that time—and had been handling them for a long time; in fact, Pollock had died in the meantime—Janis never mixed his European masters with his Americans.

Well, that was one first. From then on I really didn't know exactly what to do. Oh, I thought that I might explore some of the younger Europeans, and I had a few shows of that type. Some of my Abstract Expressionist, young Abstract Expressionist friends wanted to show in the gallery, and I was game, but I wasn't convinced that that was the ultimate goal, that I had to show secondary Abstract Expressionists.

In May I had my first important show. It was called "*New Work*," which was often misspelled in various magazines and newspapers as "New York." Anyway, it was new work, and it became a sort of programmatic show. Many of the painters, especially the two most important ones—who turned out to be the most important ones—were in that show. Others became very famous later on. Who was there? There was Jasper Johns with the *Flag*

[1955], one of the large, early flags, which now belongs to Philip Johnson. There was a painting by Bob Rauschenberg called *Gloria* [1956]. (Gloria was Gloria Vanderbilt, who was getting married to Sidney Lumet at the time. That image of the wedding with Sidney Lumet grinning and her grinning appeared three times: that was her third marriage, and not her last, as you know.) Then there was Al Leslie and Friedel Dzubas. (Leslie I never did get for the gallery. Friedel Dzubas I had for a while. Norman Bluhm I had for a while.) Morris Louis was there with a painting that did not look at all like the ones he did later. Marisol, David Budd. The interesting thing was that I did not at the time realize that the show was such a basic show for me. Although I knew already that Jasper Johns and Rauschenberg would be the stars of my gallery, I did not imagine that they would be the ones who appeared at the very beginning and would still be with me. There are no others except those two.

Rauschenberg

I love drawing, and one of the things I wanted to try was an all-eraser drawing. I did drawings myself and erased them, but that seemed like fifty-fifty. So then I knew I had to pull back farther. If it was going to be an all-eraser drawing, it had to be art in the beginning, and I went to Bill de Kooning and told him about it. When I was knocking on the door, I was hoping he wouldn't be there, so I wouldn't have to go through with it. But he was, and we went through this thing, and even though he said he didn't approve of it, he didn't want to interfere with my work.

I started with a portfolio of drawings, and he said, "No, not those." Then we went to another portfolio, and he said, "These are drawings that I would miss." So he pulled out one and put it back. Then he said, "Now, I'm going to give you one really hard to erase," and he picked out another. And he was right: I think I spent nearly three

weeks with no fewer than fifteen different kinds of erasers. And that made it real. I wasn't just making a few marks and rubbing them out.

Geldzahler

One of the key early pictures within the proto-Pop movement, perhaps the most important of all, is *Rebus*, which is a word that means "puzzle." In this single painting of Rauschenberg's, as early as 1954, there is a veritable anthology of the possibilities that are going to take over during the period that's coming up. There are rectangles of a blue-green, yellow, and a red, for instance, rectangles that anticipate some of the more geometric statements that are to come later, but rectangles that drip in an Abstract Expressionist manner. There is the inclusion of children's drawings. There's the inclusion of an entire page of Sunday comic strips, comic strips that are going to figure rather largely in some of the Warhol and especially the Lichtenstein paintings of the early 1960s. There's a reproduction of a Botticelli, the famous "Venus on the Half Shell." There are photographs from *Life* magazine glued onto the canvas. There's a poster and children's drawings, thick paint. It's an anthology that somehow organizes itself rather clearly into a single painting.

Rauschenberg

I prepared a ground of newspapers, but colored sections, which happen to be the funnies, so that I had an already going surface, so that there wouldn't be a beginning to the picture and so that it would all be additive.

You begin with the possibilities of the materials, and then you let them do what they can do, so that the artist is really almost a bystander while he's working.

Albers

My belief is that creativeness has two necessary

foundations: invention and discovery. Invention and discovery are the conditions for creative work, and therefore I said to my students, "Let's start with the materials as the only reason and not with retrospective speculations," what Rembrandt might have thought.

de Antonio

A long time ago, when I first knew you, you said, "Painting relates as much to life as it does to art." Do you still subscribe to that?

Rauschenberg

I may have said that, but I think I said you couldn't make either life or art, you had to work in that hole in between, which is undefined. That's what makes the adventure of painting.

Art doesn't come out of art, and yet you have millions of institutions that would try to prove that that's the case—and it isn't. Like the first time I was at Black Mountain, I studied with Albers. The watercolor class was a terra-cotta flowerpot, and the drawing class was an aluminum pitcher, no shading. I didn't get a nice word out of Albers until I figured out that what he wanted in watercolors was Cézanne, so I did a little Cézanne.

Albers

I preach to my students not to follow anyone, to listen to what is their inner need: this is only when we cultivate honesty and modesty. That is what I tell them.

de Antonio

Rauschenberg told me that you made him paint a flowerpot for six months.

Albers

No, I want to have them really draw a real image that is justifiable optically and mathematically, so that they under-

stand how do you get the round edge of the top round and the bottom edge is one line, a sharp line: how is that different in linear presentation.

Rauschenberg

Art is like a positive result from believing that it comes from neither art nor life. You don't work with one foot in the art book; no painter ever really has been able to other than for extra kicks and insights or to help one another.

Castelli

In my first show of Rauschenberg's, among many other paintings there was a curious couple called *Factum I* and *Factum II* [1957], and they seemed to be identical. Why did Bob paint two seemingly identical paintings? Well, first of all, it was in defense of a movement that he had actually moved away from. It was in defense of Abstract Expressionism: people felt that Pollock and de Kooning were just slashing the canvas without any rhyme or reason, without any plan. What Bob wanted to show was that nothing was really casual in painting. Even the slashes, the brushstrokes, the drips were calculated: people were after some kind of scheme, some kind of orderly procedure, even in painting that may seem extremely spontaneous.

Rauschenberg

I painted two identical pictures, but only identical to the limits of the eye, the hand, the materials adjusting to the differences from one canvas to another. Neither one was painted first to compensate for that.

Castelli

Then, too, there was the Dada reason, the Dada spirit that both Bob and Jasper had very deeply, mystifying the public perhaps with something of that kind. In fact, when we went to hang *Factum I* and *Factum II*, Bob and I felt that perhaps it would be more effective if we did not hang

them next to each other. We discussed it—should we hang them one next to the other?—and decided not to, and the reason was that it would cause something of a double take if people saw one painting and then went on and saw the same painting in another spot. It was sort of a gimmick.

Rauschenberg

Later I did another thing that was, like, part of the same thing: it was against chance. What's the name of it? *Summer Rentals* [1960]. I did four with identical material but not imitating each other, but I couldn't use anything in one that I didn't. . . . First, I had four piles of material, and the piles were identical, and I made four completely different pictures, rejecting the idea that everything is in its right place; there isn't any.

Castelli

The great event of my career happened about one month after my opening in February 1957, and that was a show at the Jewish Museum, which at that time was in a rather decrepit condition. It was a show that, as I recall, was called *New Artists: The Younger Generation*, or something like that [*The New York School: Second Generation*]. All the well-known, younger artists, like Mike Goldberg, Joan Mitchell, Al Leslie, and Rauschenberg, were included with work that I already knew. One painting that I stumbled upon that surprised me very much—I was quite stunned by it—was a green painting. I looked at the nameplate, and it said Jasper Johns. I had never heard the name. I almost thought it was an invented one. But I also didn't understand what the painting was about. I didn't recognize, as I found out later, that it was a target [*Green Target*, 1955].

Anyway, three days later I went to Rauschenberg's studio on Pearl Street to see the paintings for a show that I planned to do later. There were some large paintings that Bob had some trouble with. I asked him, could I help him

take them out, and he said, "No, no, don't bother. Jasper Johns is going to come in a few minutes to help me."

I said, "Jasper Johns? The man who painted that green painting?"

He said, "Yes, that's the one. He has a studio just down below."

And shortly thereafter Jasper Johns appeared. He was a modest, shy young man, and I was so curious to see what his paintings looked like that I told Bob, "Could we interrupt looking at your paintings and go down to see what Jasper's paintings look like?"

You know how Bob always was generous and friendly. He said, "Of course, let's go down and see Jasper's paintings first."

So down we went, and I was confronted with that amazing spectacle of targets—targets with plaster casts, targets with faces—alphabets, flags—red, white, and blue —white and gray numbers. What else? What else? Well, all the things Jasper was doing at that time. They were dated '55—most of them, the most important ones—and '56.

Johns

It had been my intention to be an artist since I was a child. But in South Carolina, where I was a child, there were no artists and there was no art, so I didn't really know what that meant. I thought it meant that I would be able to be in a situation other than the one that I was in. I think that was the primary fantasy. The society there seemed to accommodate every other thing I knew about, but not that. In part I think the idea of being an artist was, not a fantasy, but being out of this: since there is none of this here, if you're going to be it, you'll have to be somewhere else. I liked that, plus I liked to do things with my hands.

At a certain point I realized I had in my head this idea of going to be an artist and that I had had it for a very long time and that I still wasn't an artist. I saw a lot of people

who were artists or who said they were artists, and I wondered what made them artists and didn't make me one. One thing was that what I did I did without any dedication to it in the present; everything I did was leading somewhere. At a certain point it occurred to me that I was leading my life right then: why shouldn't I be doing what it was I was going to be doing right then? So I worked in various ways and destroyed various things and became perhaps too serious about what I did.

One night I dreamed that I painted a large American flag, and the next morning I got up and I went out and bought the materials to begin it. And I did. I worked on that painting a long time. It's a very rotten painting —physically rotten—because I began it in house enamel paint, which you paint furniture with, and it wouldn't dry quickly enough. And then I had in my head this idea of something I had read or had heard about: wax encaustic. In the middle of the painting I changed to that, because encaustic just has to cool and then it's hard and you don't blur it again; with enamel you have to wait eight hours. If you do this, you have to wait eight hours before you do that. With encaustic you can just keep on.

The combination of this new medium—well, actually it's so old-fashioned—coincided with this idea that everything was right then. What it did was immediately record what you did. I liked that quality. It drips so far and stops. Each discrete movement remains discrete. The combination of this new material and this new idea about imagery made things very lively for me at that time and started my mind working and my arm.

That first flag—Philip Johnson has that—that first flag was a collage of paper, rags, newspaper, any kind of paper. Some things I stitched onto the canvas with thread, I think. I don't know what the canvas was. I think it was a sheet, probably a sheet, so it was very thin cotton. Things were sewn on and there was that use of enamel paint and then a change to the wax, so it's really a mess. Every time it's moved, it becomes dilapidated. Philip noticed that. I

don't think he minds though; his Poussin does something
like that, too.

Castelli

Now, I was talking about Jasper John's first show just a
while ago, and maybe I should explain what the general
feeling was in New York about painting, art, at that time and
why Jasper came in as a thunderbolt really for a few people:
myself, and, curiously enough, the Museum of Modern
Art. Barr and Dorothy Miller: all the personnel there got
wildly enthusiastic about Johns. Perhaps I myself and also
Barr and people like Robert Rosenblum, who also dug it
right away, did not quite understand what Johns was
about. Maybe we just felt instinctively that something
great was happening here.

We did not at the time understand that he had
solved—or was trying to solve or had solved, as a matter
of fact, in a fantastic way—an age-long problem of painting:
to flatten the surface, to make a painting that was merely
an object. And he achieved that by painting flags and tar-
gets, which are obviously psychologically flat. You
know they're flat. So whatever happens on that surface, if
the color recedes or comes forward, you know it's flat,
and it makes no impression on you. And there is no
background either. So we know it's there—flat. And
there's also the thickness of the canvas, that he took care
of later on in a very curious way.

Geldzahler

Here, in the triple flag [*Three Flags*, 1958], we have
what amounts to a triple pun, because we know the flags
are flat. We have three canvases, one smaller than the
next and one superimposed on the next, so that we have
three levels of flatness in a single painting, a montage, if
you will, or a collage.

I once asked Jasper Johns, when I saw this painting
at the Guggenheim Museum in exhibition, whether he
bothered to paint the stripes and the stars all the way

through on the two flags in the background, the two flags that are on the under layer. And, in his own rather ironical and perhaps perverse way, he wouldn't answer me. So, short of taking the picture apart, I'll never know whether he fooled us or whether there are indeed three full paintings here.

Castelli

Those people who had begun or had already been involved with Abstract Expressionism, like the Tom Hesses, did not really respond very well to Jasper Johns. They just thought that it was a joke. Some people thought that he was anti-American, something like that, that he was a man who protested against the symbols of America, the flag. At the time there really was no special reason for it: there was no Vietnam War on. There was McCarthy. No, McCarthy had disappeared a long time before that.

Johns

My Aunt Gladys once, when she read a thing in a magazine, wrote me a letter, saying she was so proud of me, because she had worked so hard to instill some respect for the American flag in her students, and she was glad the mark had been left on me.

There is a little painting of mine; I don't know whether you know it. It was made over a toy piano [*Construction with Toy Piano*, 1954]. It has collage, and above are these keys that actually play notes. I think it was the first painting I ever sold, actually.

I had done that painting, and then I had done the Flag painting or maybe two of them—I don't remember how many. Then, in thinking about the imagery of the flag and what it was trying to say, what it was like, then I thought of a target. Then I had—I don't know why I had this idea—I had this idea that I would have the target with these wooden blocks above as in this little, tiny painting I had done earlier. I was concerned with the approach and distance and contact with painting. So I had the idea that

these blocks could be movable; they could be attached to something behind the target that would make noise. Each one would make a different sound. That was the way it started.

Then I didn't like the idea; I don't know why. Maybe it was too difficult. I don't remember. But at any rate, my studio had in it various plaster casts that I had done for people: hands and feet and faces and things. So I simply thought of these wooden sections, instead of moving back and forth and activating sounds, as being able to lift up and see something rather than hear something. Then I saw these things I had, and I decided to put them in it. So I did [*Target with Plaster Casts*, 1955].

Castelli

Why then were we interested? What did we think was so special about Jasper? Most, as I mentioned before, was instinctive, but I could explain it to myself, and Barr could explain it to himself already at that time. It was something that went back to Dada. It was a Dada gesture to paint a flag, to paint a target with faces or with parts of the human body, including a penis that was painted in green. It seemed very Dada, and it was beautiful. Did we know that it was so beautiful, or did we just feel that it was beautiful? Could we analyze it as being good painting or not? It seemed to be very good painting. I mean, it had to be. If it had just been an interesting idea, we would not have been as struck by it as we were.

We also had been bored, all of us, I think, or many of us, by nothing happening after Abstract Expressionism. After all, Pollock was dead; de Kooning had been around for a long time, and Kline had been around for a long time, and Rothko, and so on. Nothing new was happening. All these younger people seemed to just repeat their empty gestures. There was no feeling anymore about it—Abstract Expressionism—no drive there anymore.

People in the gallery in the beginning asked me, "What's the difference, say, between a de Kooning and

some other, younger painter? Why is de Kooning so good, and why is the other painter not good? We don't understand it. What's the difference?"

Well, all I could say was, "When you just look at it, you see the strong feeling, that sense in de Kooning and the absence of it in the younger generation."

But everybody . . . the younger painters were looking around for a change. There was Larry Rivers, who went representational. There was a certain fashion of going back to representation.

So there was a lassitude about painting, about art in general, and to me at least Jasper Johns—and to Barr, say, who had never liked Abstract Expressionism—this appearance seemed incredibly refreshing.

Greenberg

Duchamp was the first artist to realize that there was such a category as avant-garde, and he became an avant-gardist in the most radical way: that is, you made yourself significant, not by producing good art, but by producing recognizably avant-garde art with shocks and surprises and puzzlement built into it.

When Duchamp made his cage of marble cubes, they looked just like sugar cubes. He fashioned them in a traditionally artistic material, marble, making marble look like an industrial product, sugar cubes. Johns followed him by casting a flashlight or a beer can in bronze and then painting them in some cases to look identical; or a coffee can filled with paint brushes: casting it in bronze and then carefully painting it so you couldn't tell the difference between the bronze version and the real version. Well, the point of that is supposed to be the point.

People reach for the far-out as a context and a category when there's not enough inside them, not enough inspiration or impulse to send them into the far-out by accident, as it were. Monet and Cézanne and the Impressionists and Picasso and Matisse and Miró and Pollock were far-out out of inner necessity, and there was no intention

to shock or confound in their art. They were very much disappointed when people were shocked or confounded or puzzled by what they did. With the Futurists and Duchamp something different begins. These artists welcome the kind of scandal provoked by the far-out, and they aim for it. And by curious irony—and this paradox runs through all human affairs—the Futurists and Duchamp and most of the Surrealists and most of the Dada people were far more academic in ultimate effect than the earnest artists, than the dead serious ones.

de Antonio

What about Dada?

Johns

"What about Dada?" What kind of question is that: "What about Dada?"

I think all work has relationship to other work. An idea around what you're talking about is the possibility that I deliberately behaved in a Dada fashion in my work, which is not true in that I didn't know anything about Dada at that time. I didn't even know the term, I must confess, and Bob Rauschenberg did. He explained it to me, what Dada was, and then I thought I should find out firsthand what it was. So Bob and I went down to the Arensberg collection in Philadelphia to look primarily at the Duchamps; I didn't know Duchamp's work though Bob did to some extent. I found it very interesting, and I'm not embarrassed by any relationship that anyone could make between my work and Marcel's. My work is not imitative of his, and I'm entirely sympathetic to everything that he has ever done, I believe. But I don't think there is any stylistic similarity. The Dadaists were Dadaists by saying they were Dadaists. I'm certainly not.

5. Everybody talks about the art establishment

Philip Johnson

I think the collectors have made an enormous contribution, not only to the market but to painters themselves. These people that buy, that set standards, make everyone else itch to emulate. The itch to emulate, the desire for status, is certainly one of the main things in our society. It's not true that you get rich by buying paintings and reselling them later. Nevertheless, if you think it's true, it'll help the market; it'll start a sort of circular motion. I find that if I look at a photograph of Ethel Scull, and behind her back hangs a particular painting, I am more apt to take a look at that particular phase of that particular artist's work than I would if I hadn't seen it behind her back. So each of us goes and looks at each other's collections, and that gives us all a sense of escalation, if you will.

It's unbelievable what the collectors have done to establish a market, but more than a market, I think it helps

the whole art world to have the younger artist think his work could be in the Scull collection or so-and-so's collection.

Olitski

I remember hearing Adolph Gottlieb on a panel once at NYU, and Adolph said, in effect—I'm not quoting him exactly—"I don't paint for the masses. I paint for the elite. The masses are not interested in what I do. They won't understand this kind of painting that I do, and it wouldn't come through to them."

I understood perfectly what he meant, and I was totally sympathetic. But the audience, which was not quite an audience of proletariat workers but an audience of school of education, art teachers, or art teachers to be, were going out of their heads with rage just at the mention of the elite.

I think there is an elite, and there always was an elite for painting or for good music or for good literature. For a long time there has been, and I don't see anything wrong with it. What it means to a lot of people, the elite is the wealthy or something like that. Adolph, I don't think, was referring to an elite of the wealthy, where the people run the government or something like that, but to those people who are concerned and interested in the most sophisticated, meaningful painting there is.

Leider

Each time that I went to [Richard] Serra's show, there were only artists there, other artists.

Motherwell

It was very evident that behind the Iron Curtain there are all kinds of painters who are dying to see more of modern abstract art, who try in various ways to make it, and so on. Now, let's say that they're young, in their twenties. There would be nothing in their cultural background to lead them to want to do this. It certainly has to

be some direct perception, as direct as when one sees a beautiful woman and is attracted. This has nothing to do with social circumstances, but something that is in another level of existence.

If one compares modern art with the art of the past, one, it's an art of individuals as compared with a tribal art; second, it's not an art in the interest, despite what young radicals may say, of any particular class, which is to say, the people to whom it appeals are people who are after a realm of spirit that transcends classes, precisely the same way that sex transcends classes. I mean, I would not accept that there is a proletarian sexuality and a bourgeois sexuality, et cetera, in terms of the immediacy of the experience.

The young radicals' argument was parodied to me in the 1930s by a Marxist who said that Picasso is a traitor to the working class. That is to say, to the degree that he made objects that gave sheer pleasure, he made human existence more endurable and distracted people from the real task, which was to bring about a revolution. It was obviously a simplistic argument.

I would say the subtlety of my argument would be that if the aspirations of revolutionary change are for greater individuality, greater spiritual growth, for expressions that are humanistic, or to use a more immediate, New York word, for an existence that is more *menschie*, then certainly part—and a main part— of the struggle of art has been to make an art that is direct, simple, humane, unconnected with powers that be in their essence, and so on. To the degree that it is connected with the bourgeoisie via the marketplace and so on is not necessarily an artist's problem.

Newman

The great thing about painting as an art is that this primitive structure is the essential nature of the enterprise. There is no real industry waiting. (Perhaps it's now developing. I'd hate to see that happen.)

In other fields, for example, writing, the man's a poet. He presents his work; the publisher says, "Sure, we'll publish the poetry, but there's no real money in it. But you're a writer, why don't you write us a novel? You can write." And in order to get his poetry published, he gives up his art and becomes a novelist, because the thing begins to move in terms of motion picture rights and serial rights and their industries. Painting is still a primitive business.

Hess

I really don't know why art suddenly became a possible thing for an upper-middle-class man or woman to buy. I think that has something to do with the media: news, magazines, and television. The media are always on the lookout for some kind of sensation of news and some kind of vitality. Of course, American art had tremendous vitality. I think it went from the studios into the media and then bounced to the collectors.

Scull

My first purchase after the Abstract Expressionists was to buy out almost completely the 1958 show of Jasper Johns. He did very poorly in that show, and I couldn't understand why it wasn't selling. I thought it was so marvelous, because he was using the technique of Abstract Expressionism, but he was the hatchet man who really was the moment that Abstract Expressionism started to come to the realization that something new was happening.

I told Castelli I wanted to buy the whole show, and he said, "No, no, that's very vulgar. We can't do that." So I bought about eight things, and then I went down to the studio after that and bought more.

Kramer

Everyone talks about the art establishment, and I don't know anyone who doubts that it exists, but it is a

very difficult entity to define. At one end of it, you have the talent that's required to have the art itself; at the other end, you have the enormous sums of money that animate the whole scene; and in between, you have the sort of phalanx of dealers, museum curators, critics, collectors, and in some cases writers on art who are themselves collectors and—how should one put it?—tipsters for dealers and collectors.

I myself really don't subscribe to conspiracy theories of history and that includes art history. I think it's naive to suppose any one single critic or one single museum director or one single collector can establish a no-talent artist overnight and establish a big market for his work. It doesn't work that way. It works in a more complicated way.

It works the way everything else in the upper crust of society works. There's a kind of "interlocking directorship" (using those words in quotation marks) of people who stand to gain certain increments in privilege and profit and prestige, and in some cases the social prestige is as important, or even more important, than the money involved. People like the Sculls I don't think went to the art world to make money. They went to be somebody, and they had a very canny understanding of what it takes to be somebody in the art world. It takes money, it takes a certain kind of bravado, and it takes a certain capacity not to mind having other people think that one is terribly vulgar, what, I suppose, some people might regard as insensitivity. The establishment is open to anything, to any new artist, to any new collector whose activities reaffirm the essential importance of the establishment itself.

Castelli

I had many shows of Jasper through the years, about one every two years, and prices of Jasper have gone up in a fantastic way.

Most of those paintings that I saw the first time I went down to his studio are not for sale. They are securely lodged in various collections. But occasionally one of

those paintings comes up, and the greatest collectors now of American art are not American. Some Germans, especially Dr. [Peter] Ludwig. Recently, about two years ago, he wanted a flag of Jasper's. He saw a red, white, and blue one in my apartment, and he said, "I'd like to have that flag over there on the mantelpiece."

So I said, "Sorry, but that one is not for sale."

And so he looked at me and said, "What about $75,000 for it?"

And I said, "Sorry, but it's still not for sale," Then I sold him a white numbers painting for $50,000.

Later he found a flag, and he paid $100,000 for it.

There are certain paintings of Jasper's that would be much higher than $100,000. For instance, let's take the big white flag. I think that it could easily achieve $200,000. Or the target with plaster casts that's in my apartment: that should be about $150,000, and so on. Prices are extremely high.

Johns

I heard that Bill de Kooning had said about Leo, with whom he was annoyed over something, "That son of a bitch, you can give him two beer cans, and he could sell them."

At that time I had made a couple of sculptures. I'd made one or two of a flashlight and one or two of a light bulb. They were small objects, sort of ordinary objects. When I heard this story I thought, "What a fantastic sculpture for me. I mean, really, it's just absolutely perfect."

So I made this work [*Painted Bronze*, 1960]. It fit in perfectly with what I was doing. I did it, and Leo sold it.

Castelli

Frankly, this accusation that is leveled against the dealers that they are responsible for shaping the art market is a very silly one. Naturally, we are there to do that job, and we are doing it. Now, if people—ourselves and the critics and the museums—go along with us, then there is a consensus, and we are right, not wrong. I think that we are merely doing our job.

Kramer

The whole phenomenon of the art dealer in this situation is frankly a mysterious one to me. I think that the really successful and influential ones, like Castelli and Sidney Janis, have functioned for their clients a little bit in the way that their psychoanalysts function for them. That is, they fill a void in the lives of their clients just as they fill a void in the life of their clients' culture. The psychiatrist assists the patient in discovering his own personal history, and the dealer comes on as the man assisting the collector in discovering his personal taste.

Castelli

Tom Hess of *Art News* appeared one day at the gallery. You know, all these people like Tom Hess or various critics or museum people were demigods at the time, and the fact that they would come with the rickety, small elevator up to the fourth floor of that obscure gallery was a great event for me. But I was at the same time very arrogant and ambitious.

Leider

Some German dealer who had been giving a lot of these younger Americans first one-man shows (it's surprising how many kids after 1964 had their first shows in Germany) gave a party. I was sitting next to Michael Heizer. At a certain point, Heizer said, "You know, you ought to do an issue [of *Artforum*] on duck season. You ought to get some great authority on ducks to describe the upcoming duck season and say what the best ducks are and how it compared with last season."

It was perfectly clear I wasn't getting the point, and I just looked at him in a funny way, and I said, "What's this about?"

And he said, "Do you think about art in terms of seasons?"

I still couldn't make out what he was talking about. I said, "What do you mean 'in terms of seaons'?"

"Well, you know spring is when flowers come out, and winter is when snow is on the ground. Do you think of art that way?"

I said, "No, not as far as I know."

And he said, "Well, how come you keep talking about what this artist did this season as opposed to what he did last season; and his show this season wasn't as good as it was last season?"

And, you know, I suddenly realized that the critique that these kids were laying down was extensive, and it covered the most normal assumptions about art, normal assumptions because we've normally come to it as if to assume that every year an artist will put up a show for that season.

Artists don't work that way anymore; they don't work toward shows. A show is a situation. The invitation to do a show simply becomes another situation in their lives. Winding up on the corner of Fifth Avenue and Thirty-fourth Street is the same thing as winding up with an invitation to a show. You deal with the situation as it comes up.

Scull

About 1952 or '53, I wanted a piece of art in the house, and we went to the Plaza Art Galleries. I bought a Utrillo for $245. I knew that it was a fake. I knew that, but it was fun to have. It was very beautifully done. And we hung it, and I got great pleasure out of it, although it wasn't, of course, unique; it was phony.

I was doing some gardening, and some people came along and happened to mention within earshot, "You know, this guy Scull, he's got some fantastic Impressionist collection," and I really liked it.

One day someone called and said they were doing a book on Suzanne Valadon and they wanted to have a reproduction of my Utrillo, and I got panicky, you know, and I brought it back to the Plaza Art Galleries and

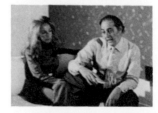

decided at that time that no matter what I bought, I was going to buy a very contemporary drawing or painting, but I would never buy a reproduction again.

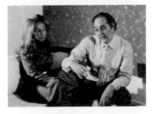

I always knew I was going to buy art. It was simply a question of having enough money for it, with three boys to bring up, with a house in the country. But I always knew. Years ago, before I was in my own business, I used to belong to the Museum of Modern Art, and when they moved a Léger from one wall to another, I used to write letters, saying, "No, it looked better in the old place," and so forth.

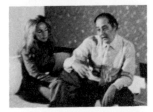

I involve myself four to five nights a week and maybe thirty-five weekends out of the year in doing nothing but getting down to studios, involving myself with artists and even artists who haven't really made it yet but just are at the beginning of their careers, so you've got to jog them along. It's not me and Ethel even. As a matter of fact, we don't have a Scull family buying commission. I buy what I like, because once a collection starts to involve itself with a man and a woman having different attitudes and so on, you get a watered-down kind of thing. So I have to really

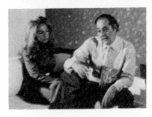

jam into my thing to the exclusion even of Mrs. Scull's sometimes not having a complete approbation. I have to do what I like, and I can't do what I like if I have to come home and discuss it; that's no way to get a character to a collection. And let me tell you something: it's not easy for Mrs. Scull to say, "Hey, you know, I saw a gorgeous Cardin" or "a beautiful St. Laurent," and I say, "Well, I don't know about that," and then that afternoon go out and buy a piece of art. You have to have a really understanding woman to get away with that kind of thing. I'm very grateful for that, as a matter of fact. I don't think my collecting could be possible at all without her understanding of what I'm doing. And then you get these wild phone calls at one in the morning: "I'm being dispossessed"; or someone needs an abortion; or someone's having a baby; or someone needs this, or that; and, you know, that's part of your involvement with the whole thing.

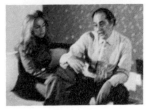

I started to buy Abstract Expressionism at a time when the movement was already under way by about seven or eight years. I certainly wasn't a great pioneer in Abstract Expressionism. I bought Kline, de Kooning, Rothko, and Still after they had already made major statements. In other words, I was very happy to buy them, but at the same time I was not involved in the beginnings of their careers, the way I was with Pop and with later art.

With the beginnings of Pop art, I became aware of the fact that collecting is not just going into a gallery and buying a painting. Suddenly I became very deeply involved with artists who later were to make a group of Pop artists, but they didn't even know each other. We had parties up here and dinners up here where a lot of these Pop artists met each other, and my purchase of their pictures seemed to be crucial to their development.

You know what happens to a young artist when you buy a painting of his: he looks at you like you're completely mad. And then suddenly he starts painting like a maniac. So there I was, already in 1963, having twenty or thirty tremendously important works of Pop art.

It has been suggested that I was responsible for changing the lives of a lot of artists. John Chamberlain came to me. I saw his sculpture, and I got to know him, and I found out that he was a hairdresser, this big, hulking fellow with a huge moustache and black fingernails. He was a hairdresser who hated his job, so that every day that he went to work it was killing him. So one summer he said to me, "I need just about fifteen weeks of steady income." (I think it was one hundred dollars a week.) "If I had that," he said, "I would be able to tell my boss to go to the devil and really do this work."

I was so impressed by his work that I said, "Go ahead." And, of course, after that summer, he never was a hairdresser again; he became a full-time sculptor.

When I met Larry Poons, he was a short-order cook. I said to him, "Well, how much do you make a week?"

He said, "Twenty-five dollars."

I said, "What are you talking about? Nobody makes twenty-five dollars anymore."

He said, "Well, what I mean is, I only work two hours a day, and that gives me enough to. . . . "

"Well," I said, "I'll give you eight weeks' worth of salary: I'll buy a painting from you."

And he looked at me very suspiciously, and he said, "Well, I'm willing to quit my job, but I want the eight weeks in advance, because if you change your mind, I'm out of a job."

Larry Poons

Robert Scull never walked up to me and said, "Here, Larry, I want you to . . . I want to help you." He did it through Dick Bellamy, and it was a dealer, and it was business. I mean, if he wants to think of himself in that way, I've got nothing against it. He really thinks that if it wasn't for him nothing would have happened. He bought a lot of people who were potentially good. I mean good. We're talking about really being good. He bought a lot of people who were potentially good, like me, twenty-three years old. There's some potential there, and you buy it.

Geldzahler

When I first became aware of the Pop artists in 1960, which is when I first came back to New York from graduate school, I was lucky enough to run into them one at a time before most of them knew about each other, and so I was able to introduce Ivan Karp to Dick Bellamy and Rosenquist, Lichtenstein, Wesselmann, Oldenburg, Warhol, and Segal, and so on to each other. Few of them knew each other independently, but they had something in common: an appreciation of American painting of the previous twenty years.

Scull

My first purchase in Pop was the work of Claes

Oldenburg. Through artists generally you get to know other artists. So my ear was always attuned to the suggestions of other artists, and I heard there was a man called Claes Oldenburg. I went down to his place—he had a store on Second Street—and I was overwhelmed by the work he had. I started to buy some drawings, and then he had a show there in 1960. I started to buy some Pop. I didn't even know it was Pop. It wasn't called Pop. It came at a moment when Jasper Johns and Rauschenberg were at their very heights, and they really opened up the doors to Pop because they used objects in their paintings that became valid works of art, and those doors opened up the floodgates to Pop artists who were using very popular images.

Hess

Pop art comes directly out of Abstract Expressionism. I think one of the great things about Abstract Expressionism is an attempt to get away from the arty part of art and to break through style, to break through conventions and to get to something real both inside the artist and in the public. The Abstract Expressionist painters all adored billboards and highways. De Kooning's pictures are often named after highways. David Smith used big farm implements. There was this idea of getting through to a larger America which perhaps contained a reality. This is a romanticism, but this was what they had, or this is what they were stuck with, or this is what America stuck on them. And this was talked about all the time. This was a well-known longing, this longing to break through.

I think the Pop artists picked it up, and I think they distilled it. In other words, they made something out of it, but I think it lost some of its depth and some of its nuances and some of its complexity. I'm all for the Pop artists; I think they have made terrific images, but they have restricted themselves by the image itself.

Scull

I heard about James Rosenquist through Richard
Bellamy, and I went up to see him, this North Dakotan
who had lived in Minnesota. He showed me some Ab-
stract Expressionist pictures that were fairly wild, but in
the heyday of Abstract Expressionism they weren't really
tremendous. Then he brought out three or four new
pictures that he had done which were completely differ-
ent from anything I'd ever seen. They sort of used
enlarged images of everyday objects in a kind of Cubist
statement, almost like a Léger except, of course, done
thirty-five years later.

I saw one picture, and I said to him, "I like that
painting. What is it?" I saw four men on the corners of the
picture. They were sliding out of the picture. In other
words, only parts of their faces were visible. I said,
"What's this all about? Why didn't you put the people
right in the center?"

He said, "Well, the name of this picture is *Four 1949
Men*. This is 1961, so they're sliding out of the picture.
People who are in the center of pictures today are
1961 people."

I said, "How much is it?"

He said, "I don't know."

I said, "What do you mean, you don't know?"

He said, "Well, I've never sold a picture before."

I said, "Well, how much do you want for it?"

He said, "I don't know." Then he called his wife, Mary
Lou, down, and he said, "How much is this picture?"

She said, "I don't know."

I said, "I'll tell you what: I'll be back in about a week,
and that will give you time to see what you want."

And he said, "Wait a minute. You wait here. How
about $200?"

And I was floored, because the picture obviously was
one that he had worked on for a long time.

I said, "$200!"

He said, "Wait a minute. Maybe that's too much."

I said, "No, it isn't. I think it's worth more than that."

Well, I paid him $250 for the picture called *Four 1949 Men*. I didn't take the picture with me because I had a small car, and when I came back a week later to get it, he thought I wanted the money back, because the first thing he said to me was, "Listen, I spent that money you gave me." He was very upset.

"I don't want the money back," I said. "I saw another picture when I was here last week. I'd like to take a look at that."

He thought I was off my rocker. He said, "You mean, you want to buy another one?"

I said, "Yeah," and I bought a second picture from him, called *The Light That Won't Fail*.

Geldzahler

One of the greatest experiences I had in those early years of the 1960s was meeting Andy Warhol for the first time. Ivan Karp took me to his studio, and we became fast friends immediately. I remember very well that first day seeing this painting of Dick Tracy in Andy's studio. I said to him that I had seen the work in New Jersey of another artist, Roy Lichtenstein, who was also working from comic strips.

Andy had three or four other paintings besides *Dick Tracy* [1960]. There was a Nancy and Sluggo, and there was a Popeye, and, again, they were closer to Abstract Expressionism. The paint was allowed to drip, the message was unclear. There's a kind of accidental aura about them. At the same time in his studio I saw paintings of Coke bottles. I saw a before-and-after nose operation. And I recognized with a kind of thrill that I was in the presence of, let's say, a genius or someone who epitomized the age in a very special way. That's been my experience with Andy over the years.

Andy picked up the images, for instance, of Elizabeth

Taylor and Marilyn Monroe in two paintings, one in color and one in black and white. He repeated them in a way a film strip repeats an image, one after the other; the way a television image comes at you electronically, second by second; the way a million copies of *Life* have the same cover running off the press one after the other. It's a contemporary kind of feeling in a contemporary image. The electric chair painting, which he calls *Orange Disaster* [1963], is, I think, perhaps the most powerful single Pop art painting that I know of, and it brings to mind the remark attributed to Elaine de Kooning, that the only American contribution to the history of furniture is the electric chair.

The Campbell's Soup Can could be called perhaps the *Nude Descending the Staircase* of the Pop movement. It's the image that *Life* magazine uses to sum up art in the 1960s. It's the image that comes to many people's minds when you say Pop art in the first place. Here are thirty-two hand-painted Campbell's Soup Cans [1961–62] by Warhol. They are painted very flat, very dead on. Andy at the time said he used the Campbell's Soup Can because every day for lunch he had exactly the same thing: a sandwich and a can of Campbell's soup.

Scull

When I met Oldenburg, I started to buy, and then I heard someone mention to me about a fellow called Andy Warhol. I went to see him in 1961, early in 1961, and he said to me, "I want to sell you some paintings."

And I said, "What do you mean, 'some' paintings?"

He said, "Well, I don't care how many you take, but I need $1,400."

I said, "What do you think this is?" I couldn't get used to the idea.

He said, "Look, here are five pictures."

I was really overwhelmed by the art. The art was sensational.

Then he said to me, "Well, if that won't do, here's

another one. As long as it's $1,400, you can take whatever you want."

I said, "You're completely mad," but my first purchase of Warhol consisted of $1,400 worth of art.

I began to realize that these men who didn't even know each other and didn't even paint like each other, no matter what you call the Pop artists as a group, they are so diverse in their techniques, but the pressures of the times, the reaction against Abstract Expressionism, created through this pressure a whole group of men who were working in an entirely new direction that became known as Pop art.

Kramer

It's often said about Pop art that it's all put on, that people are being put on; it's a gag, a gag that the squares have mistakenly taken seriously. While there's something to that, my own theory of the put-on in modern culture, the way our culture conducts its dynamics, is that the put-on is always to some degree a try-on. What is being tried on is an idea to see how far it will go. In a sense, nothing can be a permanent put-on. If it's tried on and there's a public for it, it's no longer a put-on; it has to be taken as a perfectly serious statement, it exists, it's what it is.

In a way, the critical point of view that says, "Oh, this is all just a put-on," is really avoiding the main issue, and that is, What is the status of a serious artistic idea in this culture? Is it something that the artist himself creates, or is it a kind of temporary transaction between an artist and the public, mediated by all the so-called pacemakers, whether critics, museum directors, collectors, and so on?

I think more and more our culture is dominated by these temporary transactions that have no real spiritual substance. To that extent, the artists of the New York School were practically Franciscans by comparison.

Pop art is an important phenomenon, but it's a

phenomenon that belongs to the history of taste more than to the history of art, I think. It was a release for a lot of people from the rather puritanical restraints of modernism that the New York School abided by so strictly. The whole abstract aesthetic of the New York School was full of "thou shalt nots." It imposed a kind of abstinence on the whole visual vocabulary of painting, and Pop came along and said to a lot of people for whom the whole modern aesthetic is just too difficult and too devoid of fun, it said to all these people, anything goes. It released them from a certain kind of seriousness, a certain kind of solemnity, but I think, as an artistic statement, as an artistic vision, it's totally facetious.

de Antonio

When I first knew you, you weren't painting, and then you did become a painter. Tell me why that happened and when it happened.

Andy Warhol

Well, you made me a painter.

de Antonio

Let's have the truth.

Warhol

That is the truth, isn't it? You used to gossip about the art people, and that's how I found out about art. You were making art commercial, and since I was in commercial art, I thought real art should be commercial, because you said so. That's how it all happened.

Johns

I think the idea of Pop art isn't very interesting, because I think the idea of any art isn't very interesting. The things that have interested me in painting and in thinking are the things—of course, I will tell lies here—the things that can't be located, the things that turn into something

else while you locate them or are located so nicely that you know they can't survive. It's never interested me just the idea of forming a territory or a thought and defending it. It seems to me that Pop art, the term *Pop art*, suggests that everything is certain. I don't enjoy that.

Greenberg

Pop has the same something, an attitude similar to the Dada and Surrealist artists, who deliberately used academic means to illustrate unconventional things, like Dalí and Magritte and Delvaux, whose art I don't sneer at by any means, but, then, they made better pictures than most of the Pop artists. With the Pop artists, there's the trick of saying, "I'm going to make it look just the way the cheapest art looks, but with a difference and a twist," and so forth. People like Warhol and Lichtenstein do paint nice pictures, but most of them are just spinning. They don't know their ass from their elbow. Still, in all, you hear them out instead of missing them.

The Pop artists paint nice pictures, better than bad Tenth Street painting, most of the Tenth Street painting of the 1950s. All the same, it's easy stuff. It is. It's minor. And the best of the Pop artists don't succeed in being more than minor. It's scene art, the kind of art that goes over on the scene.

The best art of our time or any art since Corot, not just since Manet, makes you a little more uncomfortable at first, challenges you more. It doesn't come that far to meet your taste or meet the established taste of the market. The Pop artists almost knowingly come more than halfway to meet your taste, just as Dalí did.

Warhol

Brigid [Polk] does all my paintings, but she doesn't know anything about them.

de Antonio

What do you mean, Brigid does all your painting?

Warhol

Well, Brigid has been doing my paintings for the last three years.

de Antonio

How does she do them?

Brigid Polk

I just call Mr. Goldman, and I just tell him the colors. Or I go down there, and I just choose them from anything that's lying around—a Stella poster, you know—and I just pull off a piece, and say, "That color and that color." I take Polaroids of the four flowers, and I switch the colors around and superimpose four cutouts one on top of the other. Take a picture and have Mr. Goldman do it.

Warhol

But Mr. Goldman's dead.

Polk

No, his son.

Warhol

The reason we can say Brigid's done it is because I haven't done any for three years. So, when the papers say that Brigid's done all my pictures, Brigid can say she does all my pictures because we haven't done any.

Polk

Andy does all his own ideas though. That's his art.

de Antonio

You said all people are the same and that you wanted to be a machine. Is that true?

Warhol

Is that true, Brigid?

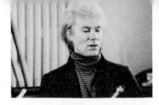

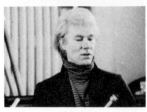

Polk

No, he just wishes it was all easier. He said to me last week on the phone, "Brigid, wouldn't it be nice if in the morning we could get up and at ten o'clock go to all the movies and then all the galleries? And just think, it would be just like Teeny and Marcel used to do."

de Antonio

How did you actually paint a picture when you started doing them six or seven years ago, before Brigid did them? Tell me about the electric chair, which is one of my favorite paintings.

Warhol

Oh, I just found a picture and gave it to the man, and he made a silkscreen, and I just took it and began printing. They came out all different because, I guess, I didn't really know how to screen.

Geldzahler

Ethel Scull 36 Times [1963], I think, is the most successful portrait of the 1960s. It's a new kind of look at a single human being from thirty-six different points of view. It's obviously influenced by the cinema and by television. Andy had the rather simple and beautiful idea of taking the subject to one of those photomat machines.

Ruth Ansel

Andy and I had seen a bit of each other in the early 1960s and were rather excited about breaking the traditions of formality of portraits done in magazines to that time. As art director of *Harper's Bazaar*, I had a series of pages to do of young, new personalities in the arts, and I thought I would give him the assignment and see whether he could come up with something that would look different than anything that had been put on fashion pages before. Out of that discussion came the words *photomat*

machine. It was the machine doing the work and not the artist with his particular individual stamp on the page that fascinated me. So we just decided to go ahead and see what came of that.

I gave him the list of names, the people to be photographed, and he took them to some photomat machines that he found on Forty-second Street and came back with a series of portraits: out of focus, front, side, feet showing, heads cut off, everything wrong, and everything right because of it. I loved them and just put them down on the page in the most honest way I could: not cropping, not making them look better, and certainly no retouching. The people he photographed were Larry Poons, the painter; Lamont Young, the composer; Henry Geldzahler; Edward Villella, the dancer; Rosalyn Drexler, the playwright; and Sandra Hochman, the poetess.

Ethel Scull

Bob had asked Andy Warhol to do a portrait, which sort of frightened me, naturally, because one never knew what Andy would do. So he said, "Don't worry, everything will be splendid." So I had great visions of going to Richard Avedon.

He came up for me that day, and he said, "All right, we're off."

And I said, "Well, where are we going?"

"Just down to Forty-second Street and Broadway."

I said, "What are we going to do there?"

He said, "I'm going to take pictures of you."

I said, "For what?"

He said, "For the portrait."

I said, "In those things? My God, I'll look terrible!"

He said, "Don't worry," and he took out coins. He had about a hundred dollars' worth of silver coins, and he said, "We'll take the high key and the low key, and I'll push you inside, and you watch the little red light." The thing you do the passport with, three for a quarter, or something like that.

He said, "Just watch the red light," and I froze. I watched the red light and never did anything. So Andy would come in and poke me and make me do all kinds of things, and I relaxed finally. I think the whole place, wherever we were, thought they had two nuts there. We were running from one booth to another, and he took all these pictures, and they were drying all over the place.

At the end of the thing, he said, "Now, you want to see them?" And they were so sensational that he didn't need Richard Avedon.

I was so pleased, I think I'll go there for all my pictures from now on.

When he delivered the portrait, it came in pieces, and Bob said to him, "How would you like . . . don't you want to sit down at this, too?" because there were all these beautiful colors.

He said, "Oh, no. The man who's up here to put it together, let him do it any way he wants."

"But, Andy, this is your portrait."

"It doesn't matter."

So he sat in the library, and we did it. Then, of course, he did come in and did give it a critical eye. "Well, I do think this should be here and that should be there." When it was all finished, he said, "It really doesn't matter. It's just so marvelous. But you could change it any way you want."

What I liked about it mostly was that it was a portrait of being alive and not like those candy box things, which I detest, and never ever wanted as a portrait of myself.

Warhol

Did you know they sold their paintings?

de Antonio

I heard they sold them to some Germans.

Polk

$3,000,000.

de Antonio

And they paid $100,000 for that portrait, Andy?

Warhol

Less.

de Antonio

How much did she pay for her portrait? Surely $5,000.

Warhol

Hers was so much fun to do.

de Antonio

But how much did she pay you?

Warhol

I don't know. $700.

de Antonio

$700 for that portrait!

Warhol

I'm not sure.

Pavia

People don't know in the 1940s, when we were starting, Franz Kline made a living making portraits. He used to make portraits on Macdougal Street. I made portraits; I used to make a living at it, too. Bill de Kooning made portraits. A lot of us did. It's always been the bread and butter of artists. We didn't make it that commercial. We didn't knock them out. We just did them when we really were excited by the subject. I think Bill de Kooning made some terrific portraits, and they're all people he liked. Franz Kline made an awful lot of them; in fact, too many maybe. I only made ones I liked, and others felt the same way. It was not a hack way, making portraits.

Geldzahler

The Sculls in their front hall have a double portrait of themselves by George Segal, which replaced a portrait they had of me for a couple of years. I remember Ethel calling me before she went out to Segal's to be cast, wondering whether she should wear a real Courrèges or a copy. I think she wore a copy; she didn't see any point in destroying a real Courrèges for such an ephemeral purpose.

As curator in a museum, I get the question about once a month from the wife of a Supreme Court justice or from a governor, from somebody who has to have an official portrait done, who can we get today to do a portrait that will have meaning or that will stand over a period of time. It seems to me that Larry Rivers, Jim Dine, and Andy Warhol are the natural portraitists of our age, but most of the institutions of government haven't gotten around to understanding that yet. I think a close look at the kind of personality that's revealed in a painting such as *Ethel Scull 36 Times* should help people to make legitimate portraitists of many of the Pop artists.

de Antonio

Why do you choose the subjects you choose? What led to the series on death: the car crash and the electric chair?

Warhol

I think it was on July 4th, and the radio kept saying, "Six hundred people are dead on the highway." I guess that's what did it.

de Antonio

What about the electric chair?

Warhol

Well, that was the time they stopped killing people in

the electric chair. (Or was it before?) So, I thought it was an old image, and it would be nice.

de Antonio

You ran into some practical political problems at the World's Fair in Flushing.

Warhol

I guess I painted the most wanted men.

Johnson

The story of Andy and the most wanted men was a peculiar political event of 1963. We had at the World's Fair, at the pavilion that I did for New York State, a space on the wall that I hired six —was it six?—great artists . . . I just gave them the space and said, "Do what you want to." And Andy did a dramatic sequence of the most wanted men. It just happened, though, that in the research it turned out that these men were not wanted. They were all well and happy and living with their dear families. Perhaps more important politically, they all had Italian names. How it got to the government, I don't know, but they called me in anguish, and we had to drop the thirteen most wanted men. I never looked into whose fault it was, whether they were wanted or not. We just dropped the idea.

Leider

It seems that my ideas about Pop art change every year. Right now I sort of think of it as a kind of reintroduction of a Surrealist content, and in a way, almost a reintroduction of poetic content. There again, you run into the problem of the expression *Pop art*. What really counts are Warhol and Lichtenstein and Oldenburg. Those three guys were doing very different things. Lichtenstein was getting right back to an enormously strong suggestion of figure-ground relationships. Oldenburg's great contribution, I think, was the loosening of the possibility of

literary art. What you get in Oldenburg are a succession of extraordinary metaphors. Warhol's life-style produced certain kinds of works. He moved into film, he moved into silkscreening, he moved into a whole variety of things. He moved into a discothèque. It simply suggested that the world was going to have to come back into art if it was going to have any meaning at all.

Greenberg

In the last 150 or 200 years, you can say that most of the art, most current art that's in the foreground of public attention, current art done by people under fifty, is not the art that will last. That's something to do with the history of taste in our times and the past century and a half. The fact that taste when it comes to contemporaneous art is so fallible has sunk in. People try not to make the same mistakes as were made in the past, but it's no use. You go on making the same mistakes again and again. You say, "I'm not going to miss the next Cézanne" or "I'm not going to miss the next Pollock," and then you go looking for the equivalent thing in the next Pollock or the next Cézanne and you make the same mistake all over again, because the equivalent thing always comes up in a surprising way. It always crosses you up.

Just as very little is learned from history, so very little is learned from art history. So the same mistakes go on being made, but, of course, with certain differences. Artists, great artists in our time, the few of them, aren't quite as hard up for money. Let's say, they get recognized a little faster in terms of sales than they used to—not always, but on the whole. But essentially, it's the same old thing. Certain heroes on the art scene today will diminish with time, just as certain heroes of the 1950s have and heroes of the 1940s, and people will say to themselves again, "We're not going to miss out again the next time." They're going to do the same thing, look for the same stigmata. Looking at contemporary art, and to some ex-

tent at past art, involves a readiness to be surprised.

These movements of the 1960s don't have progeny. The Pop art leaders—and this doesn't say anything about their intrinsic quality, but it's something to be noticed —nothing follows after Pop art.

de Antonio

Do you feel that the kind of painting that most painters are doing today, like the color-field people, is a form of art for art's sake with no relationship to life, as opposed to Pop, or whatever you call the kind of work you do?

Warhol

I think all the art that's being done now is so terrific.

de Antonio

Does stained color mean as much to you as an electric chair?

Warhol

Oh, yeah. Don't you think stained color is terrific?

de Antonio

Were there any people in Henry's show whose work you didn't like?

Warhol

Oh, no. I like everything.

de Antonio

What did you like best about the show?

Warhol

I never did see the show.

de Antonio

You never went?

Warhol

I went to the opening, but I didn't go inside. I pretended to be Mrs. Geldzahler and invited everybody in. I just stayed on the stairs and didn't go in. So I never did see it.

Hess

I think the exhibition at the Metropolitan Museum is a big, beautiful, optimistic, bouncing, gorgeous show of a big, beautiful, bouncing, gorgeous, optimistic American society. It had nothing to do with American painting of the 1940s, little to do with American painting of the 1950s, and it was the attitude of the swinging '60s. There's nothing wrong with this, if the organizer of the show, Henry Geldzahler, had not written a catalog and made statements to the press and spread a few rumors that this was not an exhibition, but, on the contrary, a laundry list of who was in and who was out.

And, of course, the exhibition has no such value: it omitted many fine artists. It used a standard which was called "deflectors," which reminds me of shin guards for hockey players more than artists. I'm sure that in—well, I was going to say, fifteen years, but it might be fifteen minutes—the whole scene will have changed, and there'll be other people making other shows, just as happy but with a different lineup, equally right and equally wrong. The show itself was beautiful.

The idea of Action Painting is that in the action comes the painting; and in one of the magazines, Henry Geldzahler said that he didn't know what the show was going to be like until he had it up. He had no ideas. Like you get a bunch of pictures—like an artist might get a bunch of materials for a collage—and you put them around, and suddenly—bam!—there's the art. There's the exhibition.

de Antonio

Did you see what Tom Hess said about Henry? He

called him an "action curator." He said the real art was making the exhibit, not the painting.

Warhol

Oh, we know that. All the critics now are the real artists.

de Antonio

And the dealers, too?

Warhol

Yeah, the dealers are the new artists, too.

de Antonio

Are there any critics you like?

Warhol

I like the kind of critics who, when they write, just put the people's names in, and you go through the columns and count how many names they drop.

Polk

Suzy.

Warhol

Suzy is the best.

de Antonio

The best critic?

Warhol

Yeah, because she's got the most names.

Leider

Henry was weak about sculpture through the whole show. He simply didn't know what to do with it. He kept planting it like trees in places; you knew if you saw a room with a lot of David Smiths in it, it was an important room.

Frank Stella's room had a tremendous number of Smiths in it. So did Pollock's room. Those were the high points. He kept using it to carry messages. If he didn't like an artist, he put a bad sculptor in the same room with him.

Kramer

One of the basic problems of Geldzahler's show at the Met—I think it's reflected in every part of it—is the question it raised about the qualifications Geldzahler had to organize such an important exhibition in the first place. He's a man whom everybody finds charming and amusing, and I suppose he's our number one camp curator in the New York museum world; his reputation consists largely of facetious publicity. He's made absolutely no intellectual contribution to the art world, to the museum world. He's published nothing of any significance. He has no bibliography. He's written no critical essays that amount to anything. Nobody takes him as a mind seriously. He made his way in the art world through friendships with artists, the Pop artists primarily, whom he has now, in the catalog of this exhibition, come to agree are not major artists, which in turn raises the question why they're in the show at all, because the show is supposed to consist only of these deflectors, and in the catalog he says, well, they haven't deflected anybody. They haven't produced a second generation of artists who can build on their work. It turns out to be a footnote after all, but it's the footnote that launched him, so to speak, so for that reason it's given special status.

Johnson

I just don't like the title of the show. I think it should have been called *Henry Geldzahler's Choice: 1970*. Then there would have been no discussion about omissions. Everybody knew this was a whim of a very individualistic man. I would have done a different list, but it would have been just as controversial.

I like the Museum of Modern Art's old formula: the

Sixteen . . . Thirteen . . . Fourteen Americans. You don't have to choose them. You don't have to agree with them. It could have been called *Dorothy Miller's Choice*; everybody knew it.

6. All good paintings have lives of their own

Castelli

Now, the Stella story is really quite amusing. Somebody back in the early fall of '59 mentioned this young painter to me. I don't even remember who it was. (Tibor de Nagy says that he mentioned him, but I don't recall.) So I went down to the studio, which at that time was on Broadway. It was a relatively small studio with a very high ceiling and all windows. So here was this young man maneuvering around these rather large paintings, which seemed huge to me at the time but actually were ten feet by six or eight, or something like that. But he maneuvered them around in a very small space very, very gracefully. They were the famous black paintings. He showed me these paintings, and I again had the same experience that I had with Jasper Johns. Perhaps—I don't know why—but probably I understood him so well right away.

Dorothy Miller needed some young painters, and so I told her about this young painter that I had seen. So we

went together to the studio, and she was also terribly impressed and told me, "I must have these paintings in my show."

So I said, "Dorothy, you mustn't do that. He's much too young"—twenty-two years he was then—"that's one reason; and the second reason is that I have planned a show of his at my gallery in October or November."

So she said, "Never mind your show. You can find something else. And as far as his youth is concerned, well, if he's not strong enough to withstand things like that, then he does not deserve to become a great painter."

Frank Stella's paintings, as he himself later said, were really inspired by the stripes in the American flag, because he was concerned with the same problem as Jasper was. Then he went a step farther than Jasper did in making objects out of paintings by shaping the canvas.

William Rubin

I think Frank Stella's importance is that he is one of perhaps no more than three or four artists who emerged in the 1950s as abstract painters providing an alternative to what is generally known as Abstract Expressionism. Most younger artists in the late 1950s and in the '60s have been involved with a kind of painting that we could call subject painting, whether it's literally that with Pop art or whether it's involved, as recent environmental works are, with subjects in a nonpainterly form. The dominant direction since the heyday of Abstract Expressionism has not been abstract painting. There was, however, a small group of painters who came along in the later 1950s and '60s who created an abstract painting of what I think is equal force and equal power to that of the best of Abstract Expressionism, but which is very different in character. Its posture is not romantic, its method is not improvisational. It's a kind of more classical, more controlled art that in a certain sense reacted against the action conception of Abstract Expressionism and against what by the late 1950s had come to be a great deal of very bad painting made in

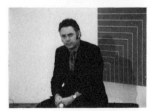
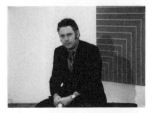

Abstract Expressionism's name. Yet, ironically, I think Frank would agree that the very roots of this art, as different as it is from the work of Pollock or Kline or de Kooning, are in that period.

Frank Stella

I knew enough about early de Kooning and some of Gorky. You could see that they were worried about Picasso and Matisse in some way, particularly Cubism. But the thing about Picasso being such a big figure was something that I just sort of passed around. That was their problem, Gorky's problem and de Kooning's, a whole complicated identity situation and struggle, and I passed by that, I suppose, largely owing to the example of Pollock.

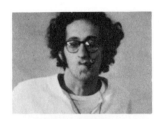

Both Pollock and Hofmann seemed to me to have solved the problem, at least they solved it in a sense for me. They came to terms in some concrete and accomplished way with what had happened with twentieth-century modernism in European painting. They established American painting as a kind of real thing for me, as something I had confidence in, something I didn't have to go all the way back and worry again about where I stood in relation to Matisse and Picasso. I could worry about where I stood in relation to Hofmann and Pollock. That seemed to me like more than enough of a struggle. That seemed to me almost as difficult to overcome—and it still seems that way somehow today. They were both strong and monumental enough to represent that kind of example, that kind of level of accomplishment and seriousness.

Having some idea of what painting is about in general doesn't bear much relation to what you actually do and the way you actually think and look at things when you're trying to make paintings yourself. And so while I had a lot of slightly abstract and theoretical ideas about Pollock, which were expressed in the things I wrote, Pollock wasn't exactly the kind of thing that influenced my painting at the time, except in a general way. In other words, I

was actually more influenced by what was in the maga-zines and around and talked about at the time: people like the second generation, like Al Leslie and Grace Hartigan and Mike Goldberg and Helen Frankenthaler. They were the ones that were most active, were getting the most publicity in general, or were the most known at the time. Those were the people I was most influenced by. Motherwell also was active and well known. Barnett Newman was probably just as active as any of those people at the time, but for some reason he just wasn't in the forefront.

Basically the Action Painters and particularly the second-generation Action Painters adopted an attitude toward painting that was based on an idea of allover attack. But they were inconsistent. They didn't really carry it out. In other words, it seemed to me that they were in a slightly compromised or slightly academic situation. They would start out with an attack, which in one way they couldn't sustain, and then they fell back on more conventional ways of paint manipulation and particularly special divi-sions to make the painting work. It was supposed to be an allover painting, but it ended up working with too much conventional push-pull of value-modeled space, where you have basically too many depth situations with one thing in front of or behind another.

The other big thing as far as I was concerned was that they all seemed to get in trouble in the corners. They started out with a big, expansive gesture, and then they ended up fiddling around or trying to make that one explosive gesture work on the canvas in some way. It seemed finally compromised by all the fixing up that went around the supposedly loose and free, explosive images.

If I criticize that or criticize the basic romance of Abstract Expressionism, the idea of alloverness and explo-sive energy and all the things that were supposed to be in it but weren't necessarily always there, it's a little misleading. I wanted to be able to have what I think were some of the virtues of Abstract Expressionism but still

have them under control. It's partly involved with having pictorial strength and controlled identity as a painter, too. But I still wanted to have energy in the paintings.

Rubin

The early pictures, like *Astoria* and *Coney Island*, were painted in 1958, just after Frank had graduated from Princeton and was living in a kind of loft downtown, supporting himself mostly by doing house painting. These pictures have a kind of boldness and directness and unwillingness to finesse their character or to try to be pretty, which is quite arresting. And, of course, as we look back at them from the context of the Met show, we see that certain of Frank's basic design concepts, the bold striping of the surface and other elements, are already there. But Frank will get rid of the brushiness of the pictures as his image clarifies itself to him in the course of 1958 and he moves into the first of his completely mature paintings, and I would call those the black paintings.

Frank's roots, as I've said, are in Abstract Expressionism, and there are in his works, even prior to those that are in the Met exhibit, elements that relate to de Kooning, Kline, Pollock, and Rothko. I think that the box in *Coney Island* has some relation to Rothko. But those two early pictures perhaps relate more to Jasper Johns than to anyone else.

Frank was, I think, very interested in Johns's work in his last months at Princeton and immediately after he graduated. Johns's flags would be the pictures we'd have to look to in that sense, because they provided a concept of a picture that would be striped, as these pictures are, and also where the stars are a kind of box, which is not unrelated to the box in the center of *Coney Island*. Johns's pictures interested Frank because of certain repetition, repetition of numbers or letters or stripes of the flag, and Frank saw possibilities in this repetition which Johns himself was not to see.

Of course, there's a vast difference in sensibilities and in aims, so I don't want to make this relationship too

close, but I think Johns also had one other importance. That is, his flag pictures and some of the other images he made were the first paintings in which the field of the pictures is absolutely identical with the motif of the picture: the boundaries of the pictures are identical with the boundaries of the flag. The flag is laid out as a flat pattern on the surface, and although Johns is a representational painter in that sense and Frank became an abstract painter, I think the notion of making the motif identical with the shape of the field, even though that shape remains rectangular in Johns's flag, lurks somewhere behind what would become the principle of Frank's shaped canvas. And that principle is, if I can define it in its simplest way, essentially that the boundary of the picture is going to be determined by the governing pattern of the surface, and that there will be an absolute reciprocity between the outer shape of the picture, which might be considered simply the outside line of a pattern that operates over the entire surface.

Stella

The use of the regulated pattern in the whole question of flatness is slightly problematic. I mean, it's a relative question. What I felt at the time—and I don't feel this now—I felt very strongly that Morris Louis, for example, and Ken Noland and particularly Helen Frankenthaler, in their use of the staining technique, there was identification with the facture and weave and all that, but it still seemed to me basically those stains read quite illusionistically. I felt I could make my paintings flat—and I wanted to make them flat—through the use of a kind of regulated pattern. The switch from the black enamel and softer bleed edge of the black paintings into the metallic paints and consequent shaping seized the surface more strongly than their paintings did and had a kind of aggressive flatness that I liked. It seemed to me to be right in that way. I'm not saying that they were better paintings, because that flatness doesn't assure quality, as Clem is

always one to point out—and I certainly agree with him.

I got very involved with the black paintings with pattern. I began making little drawings and sketches, and in some of the sketches I got involved with patterns that travel; they would move and make a jog. They built up a kind of thing that Carl Andre later called a kind of force-field situation. It seemed to be a kind of generative pattern. It moved out, and it seemed to hold the surface in a nice way. I mean, I liked the way the pattern worked. I made a number of drawings, small drawings, and I was getting ready to build the stretchers and start the painting. I already had an idea of the kind of paint I wanted to use. I was interested in this metallic paint, particularly alumi-num paint, and I was sure that that would be right in the sense that it was the kind of surface that I wanted, and I felt that this kind of pattern worked pretty well with this kind of surface. I'd have a real aggressive kind of control-ling surface, something that would sort of seize the surface in a good way. I also felt, maybe in a slightly perverse way, that it would probably also be fairly repellent. I liked the idea, thinking about flatness and depth, that these would be very hard paintings to penetrate. All of the action would be on the surface, and that metallic surface would be, in effect, kind of resistant. You couldn't penetrate it, both literally and, I suppose, visually. It would appear slightly reflective and slightly hard and metallic.

At this time [1960] I was talking to Darby Bannard down in Princeton—he was working at the Little Gallery—and showed him the drawings, and I just said, "You know, this seems pretty good. I mean, I really like this, but this part bothers me," and I showed him some corners, some little squares where the pattern ended in a small block. And I said, "I really don't like that. I don't like the way that anchors the corner in. It doesn't seem in the right kind of scale relationship. It just doesn't seem right."

He said, "Well, if you don't like it, why don't you take it away? Get rid of it?"

It was a kind of simpleminded thing, and I said, "You know, that's a good idea. I'll just take it out."

In the drawing it was very easy: I just erased a block in the corner, and I had this kind of slightly shaped or notched format. The more I looked at it, the more I liked it, and that's the way I built the stretchers and painted the series.

That was the beginning, at least for me, of shaping the outside edge. Once I started on that, once I started thinking about it, then it just sort of ran away with itself for a while. It led through the copper paintings. I guess maybe in some ways I turned back after the copper paintings.

The copper paintings [1961] cut the most space out of the rectangle, and they started to seem to me to raise a lot of problematic questions, one, about their being objects, and, two, about their being wall plaques or sculpture. It seemed to me they set a kind of limit or at least made me very aware of the limit of what you can do with shape. I made the decision then that I wanted my work to remain paintings and not get into relief or sculpture or that particular kind of literal object.

The idea of repetition appealed to me, and there were certain literary things that were in the air that corresponded to it. At the time I was going to school, for example, Samuel Beckett was very popular. Beckett is pretty lean, you might say, but he is also slightly repetitive to me in the sense that certain very simple situations in which not much happened are a lot like repetition. I don't know why it struck me that bands, repeated bands would be somewhat more like a Beckett-like situation than, say, a big, blank canvas. You could say that might be equally Beckett-like, but it doesn't seem like that to me. There was something about Beckett that seemed kind of insistent about what little was there. It also seemed to fit me.

The whole thing about pattern, regulated pattern, was to keep the viewer from reading a painting. In other words, it had to do with an idea that seemed to me to be,

if not new, at least somehow necessary to the time. It seemed to me that you had to have some kind of way of addressing yourself to the viewer which wasn't so much an invitation as it was a presentation. In other words, I made something and it was available for people to look at, but it wasn't an invitation for them to explore, and it wasn't an invitation to them to read a record of what I had done exactly. In fact, I think one of the things you could say about my paintings, which I think is probably a good thing, is that it's not immediately apparent how they're done. You can say finally it's brushed or it's sprayed or this, that, and the other, but the first thing you do is see it, I think, and not how it was done.

It's not a particular record of anything, and that may explain in some kind of way its unpopularity with the critics. I make it hard for the critics. There's not that much for them to describe. First of all, basically it's a simple situation visually, and the painting doesn't do that much in conventional terms. They can't explain how one part relates to another. There's nothing in descriptive terms for them to say or for them to point out that you, the viewer, might have missed if you were slightly untrained or not so used to looking at paintings. That critical function is subverted. I don't think that's a big accomplishment, but I think that on the positive side, and this, again, becomes very subjective but has to do finally with both the value and the quality of the painting, if this presents a kind of visual experience to you that's really convincing, I think it can also be a moving experience. In other words, that apprehension-confrontation with the picture, that kind of visual impact, that kind of stamping out of an image, and that kind of sense of painted surface being really its own surface, I think, was a kind of attempt to give the painting a life of its own in relationship to the viewer. All good paintings have a life of their own, but this had its own kind of life. I hoped that it would be immediately apparent to the viewer (although it doesn't necessarily have to be). Maybe some people, and I think a lot of people, could

miss it because you can go right by it: you can have just the impact and dismiss that impact and forget about it.

Kramer

It's a mistake to consider Noland and Stella as being a revolt against Abstract Expressionism or representing a break with it. Actually, for all the ideology that surrounded Abstract Expressionism—particularly Harold Rosenberg's (in my view) totally ludicrous idea of Action Painting, in which he tried to confer upon Abstract Expressionism a kind of existentialist glamour, a kind of struggle for identity—despite all that malarkey, the real impulse of Abstract Expressionism was toward the reduction of painting to its aesthetic quintessence. You see it particularly in Rothko and Newman and Still. But it's there in virtually all the more serious of these painters, a reduction of art to a pure vocabulary in which no other realm of experience will be evoked for the spectator except the process of making a painting. All of history, all of psychology, everything else is suppressed. You are offered a kind of easy paradise, which you enter through the eye and into which you can escape forever.

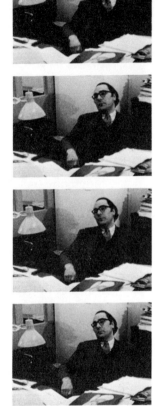

Now, once an artist begins working on this premise— and what Noland and Stella created, I think, is a rather marvelous embodiment of it—it is carried further: something very delicious is presented to the eye. You can get lost in it. But I suppose I have no taste for easy paradises. It just seems to trivialize the whole artistic enterprise to present this vast wall of horizontal stripes that more than fills your field of vision, present that as a kind of ultimate in artistic pleasure and artistic realization. Much as I admire it—and I do—and appreciate the sensibility invested in it and the effort that goes into it, it really always leaves me in a kind of despair that so much talent has been engaged in such essentially trivial purpose.

Stella

The business about my work being unfeeling and cold

and intellectual, I can't quite explain it. The only explanation I can make is a biographical one. Certainly no one would see the black paintings now as cold and calculating or very logical, but they seemed to seem that way in the context of '59 and '60. They were lean compared with some paintings, but the general look of them, if you really looked, seemed to me to have an awful lot to do with somebody like Rothko in feeling—and no one accused Rothko of being cold and intellectual.

I don't want to say I suffered from it, but certainly my biography seemed to stick in the minds of these people, certain literary types: the fact that I went to Princeton and was supported by people who seemed to be at that time at the fringe of the art world—art historians. That little support that I got seemed to drive them to fairly hysterical positions. Hilton Kramer doesn't write much about the painting: he gives you a lot of "it's cold and intellectual" and says I went to Princeton. He is interested more in the sociology of my success than anything else.

I don't know how to get at it, and I'm not sure I want to say it . . . I guess I don't mind saying it: for critics who are not first-rate, there is a tremendous assumption of artistic humility, which I didn't seem to have: too much success and being too smug about it. There is no suffering. There is no feeling. There is no questioning. I just keep doing it, and I don't have troubled periods, I don't have crises and anxieties and all that that are documented on the canvas. Basically what they're after is that it's too easy for me, so, therefore, it couldn't be any good.

Actually Clem feels that way, too. He finds, only on a much more sophisticated level, when he looks at the paintings that they're too easy for him. He gets the idea too quickly, whereas the others get no idea at all.

I can't help it; again, this gets sort of personal and, I guess, gets to be vanity in a certain way, and it gets to be a kind of perceptual psychology problem: What is it that people remember about your paintings? What image do they carry with them? What kind of impact does it actually

have on them? I can only go by my own reaction—and, of course, I spend a lot more time with them—but there are certain things that do stay with me. I don't know how other painters remember their paintings, but I have two impressions of my own paintings. One has to do, I guess, with the conception of them, which is essentially diagrammatic: I suppose I have a diagrammatic file in my head of my paintings—but not all of them. But I also have a real impression of some of the paintings as paintings, as they were actually realized. I guess that it's hard to describe what the importance of that is, but it's very important for continuing the enterprise of being a painter, because I find that when that memory or that kind of memory or involvement fades, I get very discouraged about painting and continuing painting.

de Antonio

What about Stella and Noland and Newman? Do you feel you have any relationship to their work?

Albers

No. I can see that they have a relationship to my work.

I think I can justly say that this is my main contribution to modern painting: that I have introduced this term *interaction of color*. Every layman knows if this is blue and this is yellow and I mix them together, smear them together, then I get green. Blue and yellow produce green, and I can make a bluish green and a yellowish green. That depends on the quantity the mixture contains. It happens as with human beings: we call this the parents of the mixture, and that is the baby. When a new baby arrives in the neighborhood and we go and see: "Oh, let's see the little girl." Then the neighbors get very often in a fight and say, "Doesn't that look like mama?" And the other says, "Aren't you crazy? It looks just like papa." You see, that demonstrates whether we notice first the eyes or the mouth first or the hair first or the shape first. Only when we have that middle mixture, which is a very hard thing

to arrive at, then we have these intersecting colors.

See, I have hundreds of tubes. I have sixty yellows. I have here my color charts for red. I do not mix colors. Only when I finish the whole painting, then I know if I'm a failure or not.

I'm asked all the time, what painters of today do you really respect? I say, I'm only interested in my own nonsense.

Stella

This is one of the recent paintings, and the edges here are actually fairly hard. I mean, they're not soft at all. There's not much bleed in a combination of water-soluble fluorescent and Lenny Bocour Aquatint. You probably can't see the pencil line, but it's drawn out over the canvas first and taped over the line. The tape is pulled afterwards. The color here is . . . well, it's intuitive or arbitrary or a combination of both.

The color comes largely from the way that I'm working, which means that, although they are not readily apparent here, I have a lot of mixed paint, which means I might have anywhere from sixty to eighty colors to choose from, and they're all in covered coffee cans; they're mixed, and they've been mixed over a whole year working on the various paintings. So I have a lot to draw on in the sense of I don't have to think about a color or, if I think about a range, if I want a blue-green, I can sort of run over and look at five or six different blue-greens right up and down the value scale with different degrees of blueness and greenness. So, I have quite a few choices available to me, and I just work with what I have.

This is part of the Saskatchewan series, and it's the circular Protractors that are made to fit into rectangular formats. I start with a drawing, usually a rough drawing in which I plot out mainly how the bands are going to intersect. Once I have the graph-paper drawing that will give me the widths of the bands and the units that I'm going to use, then I use a wooden beam compass, which I

make myself out of lattice, and I punch holes in it, and I measure off the lengths I need to form the units to draw the bands. I punch a hole in the wooden lattice and use a pencil and a nail at the other end and draw the pencil lines on the unsized canvas, which has been stretched over the wooden frame. Once the drawing is completed, I then use masking tape, which I tape over the line, and once the tape is down, it's ready to paint. I apply the paint directly into the raw canvas. I use a brush.

With the interlacing, particularly in a picture like this, there is no question that you have some illusionism in some kind of figure-ground relationships, but I feel that what I'm really interested in in terms of the color here is not so much in the interlacing, but rather I'm interested in using the curve to make a color travel. I feel that what keeps the push-pull from defeating the picture, what I think keeps it on the surface, is the feeling that the colors move, they follow the bands, they have a sense of direction. It's the directional sense of the color, I think, that holds the surface of the painting.

Olitski

I had been doing stain painting, black painting, and working with rollers. With the rollers I was trying to get one color rolling into another color, merging and melting with it and flowing all over the surface. So the spray painting or using the spray gun suddenly seemed the way of achieving a look that I wanted to get; and incidentally I think that the only point in using something, whether it's a spray gun or brushes or rollers or whatever, in fact, anything that you use, is solely for the purpose of getting the effect, the look of what you're trying to get at. The mechanics, the machinery, the tools, everything, the canvas, the kind of canvas, the kind of brushes, the kinds of spray guns, nozzle openings, what have you are not for their own sake, but simply to get the look you want. I've used unprimed canvas, I've used primed canvas, I've used canvas that was partially primed and partially raw: it's all

had to do with what I was trying to achieve or the look I was trying to achieve—in every period. The kind of paint that I've used will vary, too, according to some notion or feeling that you want to get out or something that you don't even know, but you want to find out: "Well, what will this look like?" What will it look like if you put down a lot of thick paint and some thin paint? What will it look like if you have this color and that color? What will happen if you do this or that or any number of things? It's that that I get some kicks out of. Why paint unless it's play in the most serious manner? But nonetheless, it's essentially playing and finding out and messing around.

I paint generally on the floor. I roll out the length of canvas depending on the width, the length of the room, and I'll work within it. I'll keep working within that space, and it's only afterwards, as I work, that I'll decide where the painting is. You know, the painting might well become just this piece here. I may well decide this is a painting here or it should be cropped here. I feel entirely free to decide or to make any change in it. In fact, after I have it stretched out, I may well then decide, no, it should be a fraction less or higher or less high or less wide, or whatever, or needs another color or still needs another accent here or there, something to accent the edge a bit. Or I may decide that the painting is the whole thing, that it needs that expansion outward.

Parenthetically, I would want to say that a lot of the thinking or what is said about painting is in retrospect. The things that you do while you're working . . . and I think a hell of a lot of intelligence, a hell of a lot of major intelligence is going on, but it is so rapid and there is such a multitude of choices and decisions and levels of feeling and thinking and whatnot going on that you can't really recapture it afterwards. So I'm not certain that my thinking about what is the essential of or what is essential to the making of a painting or what can it not do without, not exist without: was it something that went on during

the making of the painting or in retrospect? It's more likely it was in retrospect.

In any case, painting is . . . among other things, one of its essentials is color; otherwise it's drawing. But there is an area or there is that aspect of painting that is inescapable: drawing is inevitable to it. For me the one place where drawing is inescapable is its edge. By drawing, I mean it can be a straight, almost engineering kind of drawing. But the one place where it exists and you cannot get away from it is where you decide, "This is where the painting ends; this is where it exists on its boundaries." For example, say, here is the line where you decided that the painting ends; this is where it is going to be stretched. This line is a line of demarcation; it separates itself from everything else. It's a drawing. It's a drawn line. It's an edge. Edge is synonymous with drawing.

To me if you made a line within the painting, it's introducing drawing into an area where it's not essential. But my feeling is that color is essential in the sense of the essence of painting. So my feeling is that drawing, which I love incidentally and do not want to throw out of art, but since this is where it's of its essence, of its essential, is where it's appropriate. So I tend to draw along the edge.

Now, there are other things that go on here, and one is the possibility of other colors as well. It's a way of introducing other color. My concern is with possibilities and potentialities and with trying to bring in more and more of my feelings of what I want to do. I think the important thing is to do what you want to do. So I could conceivably, and I have, introduce any number of colors along the edge, you see.

My main interests are in my studio, what I'm doing. So, at the same time that you're dealing with people and you respond, I always felt it was a lie. I really don't give a fuck what happens to this student or that student. At the time I'm doing my job and, I think, really responding, somewhere I always felt it's a lie.

de Antonio

How do you go about making a painting, Larry? Can you tell me what's on the floor: is it canvas, sized or unsized?

Poons

It's unsized canvas, and it's not nailed to the floor; it's not stapled. It's just laid down on the floor, and it doesn't really make any difference whether it was sized or unsized. This just happens to be unsized. It's a little easier to work with, to lay out and take up. The paint is acrylic, Aquatech.

de Antonio

How is the paint applied?

Poons

Well, pouring. I've been pouring for about a year now. So, the combination of pouring, muscle . . . I can get an effect by doing it hard or just laying it down soft, and a lot of it has come from knowing the slight shifts in the floor that I'm working on, because gravity does pull the paint around. I've kind of gotten used to this floor; it has taken a little while.

This paint is actually pretty thin compared to some of them; say, paintings up to a couple of months ago were much thicker, and I used a great deal more pigment than I'm using now. They would take up to three weeks to dry. This has taken about a week to dry.

de Antonio

What happens to this painting now?

Poons

Well, I take it off the floor and roll it up and take it upstairs and put it on a wall and shape it.

de Antonio

How do you determine where you're going to crop it
when you take it upstairs?

Poons

By my eyes. You know, how it feels.

de Antonio

Do you feel there's any relationship between pouring
paint out of a bucket and what Jackson Pollock was doing
with a drip?

Poons

Well, sort of. It's hard to say if there's a relationship
except in the fact of control. There's always control no
matter how you do it, whether you do it with a micrometer,
with a stick, or with a bucket.

de Antonio

Is the word *risk*, then, a real word, or do you think it's
a bullshit word?

Poons

I think the word *risk* is more implicit in subjective
feeling while you're doing it when you're doing some-
thing that you don't know how to do. And, of course, if
you do it well, if it comes out well, everybody assumes
that you really knew what you were doing, that you really
know how to do this thing, and it's not true.

Olitski

Risk is, I think, in painting the equivalent of what it is
in your life, that is, are you going to take chances to come
out in the open, to be direct, to say what you have to say,
to essentially let yourself be known, or are you going to
be acceptable, safe? You know, it's a matter of being free,

or doing what you want to do or not even knowing what you want to do but finding out what you want to do; or this is the way I'm supposed to do, this is the way I'm supposed to paint, these critics, these artists, this is what is going on, these artists feel this is in. Well, fuck that. Why paint? Why do it unless there are kicks in it, and the kicks suffer risks to take chances? I think this is the way you find out what you're about, what you want to do. Now, you can paint acceptable pictures, say this is in— Pop art or something, whatever it is, Cubism, let's say, or hard-edge, so-called hard-edge painting—you can work within that mold. But I don't think the reason to be a painter is to be a C.P.A. Why do it?

It's also taking a chance to play and to wreck and to destroy something that you've done that may look good, but there is always that thing that you want to get at more. I find it very exciting and irresistible to go that further step, to see, well, what will happen. You get the thought, if over this I put this or I change this in that way, spray some more varnish on it or spray a whole pool of glop over it or over part of it or any number of things you can do, what will happen? What will it look like? Or you get the thought, before painting I'll do this. And then maybe, usually, when you risk something, it looks peculiar; it doesn't look like what you're used to and maybe it doesn't look like a painting or it doesn't look like painting that you've known, at the moment it doesn't; and that can be scary, you know, because you don't know where you are.

And it's also, I think, the most satisfying kind of experience in trying to make something, whether that's in writing or music or composing or painting. So you try it, and everyone, almost everyone, comes along and says you can't do that, or that's not right. Well, right according to whom? I think I've decided as a painter what painting should look like, not somebody else, or—yes, they can decide, too. But screw them. I decide what painting is going to look like now. And if I make a sculpture, I decide

what sculpture is going to look like, or compose music or write or whatever.

This is what the people who make art should be doing, among other things; that's principally what they should be doing. You decide what a painting is, not what some critic is used to and may be very knowledgeable as to what art is, and you present him with what is not or has not been, and he says it is not art.

Fortunately, there are one or two people in the world who will come along and be supporting, who will go right to that thing that you've taken a risk on that goes counter to what painting looks like today or yesterday or what have you, and say, "Yeah, do that; do more of that." "That's 'wow!'" You know, "you're getting here a new kind of drawing," or something, "or an articulation of surface, not through drawing, but through surface itself." But this is very rare among critics, very rare.

I think the effect of public opinion and how to deal with that may have at times been disastrous or even fatal. But even without being disastrous or fatal to some artists, they've been at least somewhat crippled. I think that it's fortunate sometimes for an artist to be ignored, to not be shown, for no one to be interested, that is, if you can survive that and not go crazy or become murderous with rage. The experience is a very useful one, I mean, in this way: You paint for years (or whatever it is you do) and no one gives a goddamn or is interested, and you can't get your work shown no matter what, and you do what you want to do partly out of that, because you can try anything out; it doesn't matter, nobody cares. So, if that habit can get ingrained in you, and I think that in someone like David Smith it did or someone like Hans Hofmann, who for many years nobody, or many, many people, didn't take too seriously. . . . I'd go and see his shows year after year, and there wasn't much attention. There are any number of instances of major painters who had that experience. And then when some recognition and success come, that habit of doing anything that I want to do and I don't give a

goddamn what you think, because in those years when nobody pays any attention to what you do, you invent a kind of audience because you have to communicate with somebody or you know someone, otherwise it's just too lonely. So you invent an audience or some ideal or being or somebody who is going to see what you're about in order to work.

For a long time there was no public opinion about me, and I think this was useful, although it can be an embittering experience, that is, nobody is watching you; you're not there in the public's eye. So I think it tends to support a kind of trying things out, and one of the things that's important, I think, to the making of art is taking the chance of being a fool or appearing so or doing something absurd.

I can think of some painters, young painters who are very gifted, you know, extremely gifted painters who have had some difficulties because of early success. One of them said to me when he wanted to change the way he painted, there was so much pressure from the public, from critics, from his dealers and so on and from himself in the feeling, "Oh, my God, my career is going to sink," or something like this. He said, "It's like growing up in public." It was very pathetic and awful. But the main thing is to grow. I think the main thing in art is to do what you want to do.

There's something I feel is important to say. For me, I think, it's very personal, and it has to do with painting and becoming a painter. I'm going to stumble about with it, but you can edit it.

I decided to be a painter when my grandmother died. There was something about that that made a number of things clear to me. You know, I was a kid—I was fourteen, fifteen, sixteen—and I had loved her very much. In some way, I feel, she was one of the few people who supported me, or, that is, she loved me. And I got nonetheless a sense of an absolutely wasted, thrown-away life, like a dead cat on a garbage heap. And it made me get a very clear

look at all the people around me, you know, family, their friends. The one thing that got through to me was the notion of, if there's anything that you want to do that's meaningful, and in my case it was painting, but I also wanted to write and compose music and make sculpture (and I'm trying to do all those things now), if there's one thing that you want to do, do it, do it, do it.

7. Make the revolution in your own life

Hess

The horrible conditions under which the New York painters worked in the 1940s with real poverty—poverty in the sense that it wastes all your time; there's not enough time to work when you're very, very broke—this has been replaced by the problems of affluence, which are just as bad. This may sound funny to someone who's very poor, but to the guy who's stuck with whatever complexities and worries come from success and the temptations and the ringing of endless telephones and the endless distractions, I don't think the situation is much better.

Greenberg

Art's tough. Many are called, and very few are chosen. On the whole, it's a tragic profession. The embittered veteran artist is the standard figure in the world of art. He's not the most conspicuous, but, I think, in numbers he's the greatest. Most of the artists on the scene are frustrated. It was that way in the 1950s, and it's that way

156

now. The few good, or the few great, artists at any time are unsure of themselves and a little frustrated—always are. It's the wholesale frustration I'm talking about. That frustration overtook the several hundred people that used to frequent the Cedar Street Tavern, and it's going to overtake the several thousand who go to Max's and St. Adrian's.

Leider

Now, one of the things in the new politics that's really interesting is that you establish your political authenticity by making a kind of change in your life: you make the revolution in your own life.

Stella

We're having a hard time busting the [1970 Venice] Biennale. There's a lot of nip and tuck going on. I've got to now send a telegram. The artists' committee, the Emergency Cultural Committee, acting out of the artists' strike, is asking the American artists to withdraw their work from this Biennale [to protest the Vietnam War].

The Smithsonian Institute is acting for the government in sponsoring the Biennale, putting up the largest amount of money. They said they didn't recognize the committee's request; they want individual requests from the artists before they'll even consider withdrawing the stuff.

The artists in the Cultural Committee started with a group of artists. Irving Petlin was the one who first presented the proposal to the open meeting, the artists' strike meeting. It was a proposal that was adopted, and then they formed a kind of committee, and Irving asked me and Roy Lichtenstein. Now Barney didn't give his approval necessarily, but he was at the meeting. There was Lichtenstein, myself, Barney Newman, Irving Petlin, and Max Kozloff, the critic. Bob Morris's name was added as he was representing the whole thing, the artists' strike general committee.

We've gotten twenty out of the original thirty artists,

but there seem to be more. We don't know how many artists were invited to this Biennale. Anyway, we have good support. Now, whether or not this is enough to close the show down, it's hard to tell right now. The Smithsonian is going to ask the artists individually. They're presenting their side of the story, and they're going to try to put the show on. They are resisting; they're not giving in.

The artists are still fairly divided. There is pressure now. There's pressure from our committee, and there's pressure from the government. The artists are caught in it; they are going to have to decide.

Leider

It's not possible, like the old 1930s leftist, to live in a lily-white house on Fifth Avenue and hold down a job with the Advertising Council and then write flaming articles for *Partisan Review*. They just won't be believed anymore. Now, at a certain point in the late 1960s, a lot of artists began to feel really deeply compromised by the structure of the art world. They somehow felt that there was something deeply inauthentic about showing work in galleries to a certain class of people that achieved a certain financial level; you know, an object became worth a certain amount of money peddled by certain people to certain people and shown in a certain regular way in museums after you got to be known by a certain group of critics. I think that, consciously or not or in various degrees of consciousness, they ascribed this entire system to a kind of ideology of art, and rightly or wrongly, I think, a lot of them associate it with the kind of abstract art that had been taking place in America.

There's nothing to stop an abstract painter from joining a political party or marching in demonstrations or even making bombs or turning over police cars. That isn't to say that the issue is a real one. What's the relationship between their art and their politics? It seems that the answers always take three forms, and they never get much

further. Either they say that the deepest implication of their art is political—and that may very well be true. . . .

Newman

Some twenty-two years ago in a gathering, I was asked what my painting really means in terms of society, in terms of the world, in terms of the situation. And my answer then was that if my work were properly understood, it would be the end of state capitalism and totalitarianism. Because to the extent that my painting was not an arrangement of objects, not an arrangement of spaces, not an arrangement of graphic elements, was an open painting, in the sense that it represented an open world, to that extent I thought, and I still believe, that my work in terms of its social impact does denote the possibility of an open society, of an open world, not of a closed institutional world.

Leider

Nevertheless, there seems to be a great feeling for a more immediate and direct expression. . . .

Scull

Rosenquist's *F-111* shows this dichotomy of American life: of the good things in life—hair dryers for little girls and all the delicious things to eat and to live with—but behind it was the drone of this F-111. So we're really a nation who likes playthings and likes all kinds of delicious, little things that industry can make for us, but at the same time we are capable of making planes that were carrying around and flying ceaselessly with a nuclear weapon in it.

Leider

There was a huge mass meeting on the political situation a couple of weeks ago, and peculiarly enough, the one proposition that was consistently condemned from the floor with low boos was the idea of the direct relationship between the art and politics, that is, that there

should be propaganda art, there should be art more acceptable to immediate political needs, et cetera. Everybody knew that that was a dead end. . . .

Rauschenberg

If I have a clock that doesn't work, there's something wrong with that clock, and that's what needs to be fixed. I'm not going to march against time.

My paintings are invitations to look somewhere else, and they have been for a long time. The new piece is, like, how not to throw your newspaper away, because that's where it is; if you are conscientious at all, the information there in one newspaper, no matter where you pick it up, blows your head. If you pay $15,000 for something, you're not going to wrap the garbage in it, right? I don't know who buys newspapers, but I know they don't read them and take them seriously, and it's the best book in the world.

Leider

Nonetheless, it's incumbent upon artists as a community to form a community that has to do with the political situation now.

Hess

There's every reason to believe that this fantastic vitality of American art will continue, and there's also every reason to believe it'll stop completely and there won't be any art at all.

de Antonio

When I filmed Andy, whom I've known for a long, long time, he said, "Well, D, I don't paint anymore. Brigid paints for me." He said painting is dead.

Poons

I experience a lot of people's paintings that are pretty wonderful art. If I didn't experience any paintings that I

experienced as wonderful art, and there was just nothing happening, then art would be dead. I mean, that whole position is an intellectual argument. It's an argument that denies feeling and perception on a very fundamental level. You know, what the guy can say is, "Painting is dead for me," and that's all right. But when somebody says that painting is dead, period—please, no dictators. That resigned and despairing position of "art is dead" is symptomatic of a lot of things that are wrong in this culture: to be resigned to the fact is like accepting it.

Frankenthaler

I think there is still a lot more to do in abstract painting. I think people who love painting, who are really involved in painting (and I don't mean things that aren't painting), I mean, the making of beautiful pictures that go on walls, I think those people are as involved in that development as they have ever been. I think there are many more sidetracks, and the time lapses are fewer and fewer, shorter and shorter. I think right now there are many good pictures to be seen that we haven't seen yet.

Motherwell

I think it's possible that painting is dead for lots of young people, but what you have to remember is that different generations are coexisting. When you think of Paris in 1915, Degas and Monet were still alive and functioning, and then there's Matisse and the Fauvist group, and there's the Cubist group, with the Dadaists about to come onto the scene, and in several years there will be the Surrealists, Mondrian and the whole Constructivist tradition, all of which have their various interdialectics, some of which lead away from painting. But certainly in the case of somebody who originally gave his heart to painting, there is no question of painting being dead for himself.

To make this statement meaningful, I think one has to say, painting is dead for whom, and I think it is possible

that for many of the most adventurous spirits, who are just coming to maturity now, it would be something other than painting that attracts them. But all painting needs to be alive is a great painter.

Johnson

"Painting," says Andy Warhol, "is dead." It seems to me that exactly the opposite is true and that Andy Warhol is the best example of the fact that it's not dead.

Of course, you don't need painters, because everybody knows that you go out and dig a hole in the desert and that's all right, so painting is obviously dead. On the other hand, it's very much alive: it's who does it and not what people say about it that counts.

There are twenty-year-old painters, thirty-year-old painters, eighty-year-old painters, and they're all painting, and they're all doing well and are happy in their little homes and little Rolls Royces. In fact, the main proof that painting is certainly not dead is the prices they're getting. At last our culture's caught up with painting. It was only Van Gogh and a few little people that starved to death.

Castelli

To say that anything is dead is just nonsense. We could say that after the great achievements of the Abstract Expressionists, of Jasper and Bob, of the color-field painters, of Noland and Louis and Stella, maybe we don't see anything on the horizon that's of the same importance perhaps. Maybe we're wrong. All the younger artists work with other media.

Robert Scull

I heard Andy's statement that painting is dead, but then it comes from the same person who said he wants mass-production painting, he doesn't want the human to be involved in it, and that it doesn't matter. For him, painting may be dead.

I find some tremendous things being done in painting.

As a matter of fact, I don't feel the way Andy does. Paintings today are as valid as they were in any period of history in the last two thousand years, the comments, the attitudes they have.

We are going to have environments done by great artists on the sides of buildings or great sculpture that's really within the scope of tremendous architecture. I think what's happening is that there is going to be an expansive measure of painting, and maybe easel painting may suffer a bit because the other is so exciting and interesting. It's involving the people in the streets. It's involving the countryside, the very fashionable ecology today, and so forth.

So painting will always reflect the attitudes of its moment if it's good painting, and bad painting is not going to reflect anything. It's going to be as dead as bad painting of fifty years ago.

Johns

A lot of people have said that painting is dead, but people continue to work; so I don't know what they are going to call it. They tend to call it painting.

de Kooning

It has been said so long about photography and television and movies. Painting has always been dead, but I was never worried about it.

A Selective Chronology, 1940–1970

Mitch Tuchman

This is a chronology specific to this book, an outline of milestones in the careers of its twenty-four speakers and the historical context in which those careers developed. For every event mentioned in the text, I have tried to provide a date.

1940

November 15, 1939–January 7. *Picasso: Forty Years of His Work*, Museum of Modern Art (MOMA) (Alfred Barr, curator).

Franz Kline paints murals for the Bleecker Street Tavern at $5 apiece plus materials.

Lenore ("Lee") Krasner studies with Hans Hofmann.

Morris Louis leaves New York, returning to Baltimore.

April 6. The American Artists Congress (AAC) endorses the Soviet invasion of Finland and ends its policy of boycotting Fascist (e.g., Berlin, Venice) exhibitions.

April 16. Seventeen members (Milton Avery, Adolph Gottlieb, Meyer Schapiro, and others) withdraw from the AAC.

April 16. Demonstrators (Ad Reinhardt and others) leaflet spectators and picket MOMA with banners reading, "How modern is the Museum of Modern Art?"

June 14. The German army marches into Paris.

September. Robert Motherwell moves to New York and studies with Schapiro at Columbia University.

October 22. Piet Mondrian immigrates to the United States.

1941

March 3–29. Vasily Kandinsky exhibition, Nierendorf Gallery.

April 22–May 20. Salvador Dalí exhibition, Julien Levy Gallery.

July. Max Ernst seeks refuge in the United States.

November. André Breton and André Masson seek refuge in the United States.

November 19–January 18, 1942. Joan Miró exhibition, MOMA.

December 7. The Japanese attack Pearl Harbor.

1942

January 5–26. Samuel Kootz shows Avery, Arshile Gorky, Gottlieb, John Graham, and others at Macy's.

January 19–February 7. Mondrian (age 69), first (and only) solo exhibition, Valentine Dudensing Gallery.

January 20–February 6. Graham shows European (Georges Braque, Henri Matisse, Amedeo Modigliani, and Picasso) and American (Stuart Davis, Willem de Kooning, Krasner, Walt Kuhn, and Pollock) painters at McMillen, Inc.

February 8–26. Mark Rothko (age 38), first solo exhibition, Artists' Gallery.

March. WPA Art Project becomes Graphic Section of the War Services Program.

March 6–28. *Artists in Exile* (Breton, Marc Chagall, Ernst, Fernand Léger, Jacques Lipchitz, Masson, Matta, Mondrian, Amédée Ozenfant, Yves Tanguy), Pierre Matisse Gallery.

June 25. Marcel Duchamp establishes permanent residence in New York.

October 14–November 7. Breton, Duchamp, Sidney Janis, and R. A. Parker collaborate on *First Papers of Surrealism* exhibition and catalog, Coordinating Council of French Relief Societies.

October 22. Peggy Guggenheim opens Art of This Century, 30 West 57th Street.

1943

April. Motherwell and Pollock work together on collages for an exhibition, which includes William Baziotes as well, at Art of This Century (April 15–May 15).

May 15–June 26. Mondrian juries Art of This Century spring show.

November 9–27. Pollock (age 31), first solo exhibition, Art of This Century.

November 29–December 11. Theodoros Stamos (age 20), first solo exhibition, Betty Parson's Wakefield Gallery.

December 9. De Kooning marries Elaine Fried.

1944

De Kooning concludes first series of paintings of women.

Motherwell begins editing *The Documents of Modern Art* series (New York: Wittenborn, Schultz).

February 1. Mondrian dies.

February 8–26. Reinhardt (age 30), first solo gallery exhibition, Artists' Gallery (he had exhibited earlier at Columbia University).

March 7–31. Hofmann (age 63), first solo exhibition in New York, Art of This Century (he had exhibited earlier elsewhere in the U.S. and in Europe).

May 2. MOMA makes its first purchases of work by Pollock (*The She-Wolf*, 1943) and by Motherwell (*Pancho Villa Dead and Alive*, 1943).

June 22. Franklin Roosevelt signs the G.I. Bill (Servicemen's Readjustment Act).

October 3–21. Baziotes (age 32), first solo exhibition, Art of This Century.

October 24–November 11. Motherwell (age 29), first mature solo exhibition, Art of This Century.

November 25–December 30. *Abstract and Surrealist Art in America*, Mortimer Brandt Gallery (Janis, curator). A book by Janis based on the exhibition (subsequently published by Reynal and Hitchcock) links American abstraction directly to the work of exiled European Surrealists.

1945

March 6–31. Gorky (age 40), first solo exhibition, Levy.

April 9–28. Kootz opens his gallery in temporary quarters with a Léger exhibition, then in August moves to 15 East

57th Street, opening with a group show (Baziotes, Léger, Motherwell, and others).

May 8. VE-Day.

Summer. Motherwell teaches at Black Mountain College, North Carolina.

September 2. VJ-Day.

October 25. Pollock and Krasner marry.

November. Peggy Guggenheim lends the Pollocks $2,000 for a house in The Springs, Long Island.

1946

De Kooning begins his series of black and white abstractions.

Kenneth Noland studies on the G.I. Bill with Ilya Bolotowsky at Black Mountain.

February. Thomas Hess becomes an editorial assistant, *Art News*. Charles Egan opens his gallery, 63 East 57th Street, with gouaches by Otto Botto.

February 12–March 7. Clyfford Still exhibition, Art of This Century.

March 15. Peggy Guggenheim agrees to subsidize Pollock for two years at $300 a month, with repayment of the subsidy and mortgage (1945) to come in the form of all but two paintings produced during 1946 and 1947.

March 30. Robert Coates, in a *New Yorker* review of a Hofmann exhibition at Brandt (Parsons, curator), first applies the term *Abstract Expressionism* to New York modernists.

Summer. Still leaves New York to teach at California School of Fine Arts, San Francisco.

September. Parsons, formerly director of contemporary art at Brandt, opens her own gallery, 15 East 57th Street,

with an exhibition of paintings by Indians of the North-west Coast and Alaska (through October 19), followed by an exhibition of paintings by Reinhardt (through November 19).

Autumn. Pollock makes his first allover poured paintings.

1947

De Kooning begins his second series of paintings of women.

Robert Rauschenberg studies on the G.I. Bill at the Académie Julian, Paris.

January 27–February 15. Kootz presents the first American exhibition of Picasso's wartime paintings.

April 22–May 31. Peggy Guggenheim closes her gallery with a Theo van Doesburg retrospective, turning the gallery's business affairs, including the Pollock debt, over to Parsons.

November 24–December 13. Hofmann exhibition, Kootz (then every year through 1966, except 1948, when Kootz was closed, and 1956).

Winter. Motherwell, Harold Rosenberg, and John Cage edit the journal *Possibilities*.

1948

Motherwell paints *The Homely Protestant* and first uses his Elegy motif.

Louis begins using Leonard Bocour's Magna acrylic paint.

January 29. Barnett Newman paints his first *Onement*.

February 26. "Old House Made New," *Life*. Photographs and article about Gorky's farmhouse/studio.

April 12–May 12. De Kooning (age 44), first solo exhibition, Egan.

Summer. De Kooning teaches at Black Mountain.

July 21. Gorky commits suicide.

Autumn. Baziotes, David Hare, Motherwell, and Rothko found Subjects of the Artist School downtown; Newman inaugurates Friday evening lecture series.

September 21–October 16. Janis (formerly with MOMA) opens his own gallery in Kootz's 57th Street space with a Léger exhibition.

October 6. MOMA buys its first work by de Kooning, *Painting, 1948.*

1949

Jules Olitski leaves New York for Paris.

Kline paints first black and white abstractions.

January 1. The Metropolitan Museum of Art establishes a Department of American Painting and Sculpture.

Spring. Rauschenberg studies at Black Mountain with Josef Albers; Cage, Merce Cunningham, and David Tudor also in residence.

May. Subjects of the Artist School closes; founding of The Club follows shortly thereafter.

Summer. Helen Frankenthaler, graduated from Bennington College, moves to New York; studies briefly with Schapiro at Columbia.

Summer. Rauschenberg moves to New York.

August 9. "Jackson Pollock: Is He the Greatest Living Painter in the United States?" *Life.* "*Number Nine* . . . is only 3 feet high, but it is 18 feet long and sells for $1,800, or $100 a foot."

September 15–October 3. Kootz opens a new gallery, 600 Madison Avenue, with *The Intrasubjectives* (Baziotes, de Kooning, Gorky, Gottlieb, Morris Graves, Hofmann,

Motherwell, Pollock, Reinhardt, Rothko, Mark Tobey, and Bradley Walker Tomlin; selected by Kootz and Rosenberg).

1950

January 23–February 11. Newman (age 45), first solo exhibition, Parsons.

January 31. Harry Truman orders construction of the H-bomb.

January 31. The Whitney Museum of American Art announces the sale of its pre-1900 collection (through Knoedler Gallery), proceeds to finance its contemporary collection.

March 27. MOMA, the Whitney, and the Institute of Contemporary Art (Boston) release a joint statement rejecting "the assumption that art which is esthetically an innovation must somehow be socially or politically subversive, and therefore un-American. . . . " Signers: René d'Harnoncourt, Barr, and Andrew C. Ritchie (MOMA); Herman More and Lloyd Goodrich (Whitney); James S. Plant and Frederick S. Wight (Boston).

April 21–23. Three-day conference at Studio 35 (Barr, Baziotes, de Kooning, Gottlieb, Hofmann, Motherwell, Newman, Reinhardt, Tomlin); later published in *Modern Artists in America* (1951).

April 25–May 15. *Talent 1950* (Elaine de Kooning, Grace Hartigan, Alfred Leslie, Larry Rivers, and others), Kootz (selected by Clement Greenberg and Schapiro).

May 21. In an open letter, eighteen painters state that they will not participate in the Metropolitan's planned exhibition of contemporary American art because it is to be selected by a national jury (Charles Burchfield, Yasuo Kuniyoshi, Leon Kroll, Millard Sheets, Lamar Dodd, among others) that is "notoriously hostile to advanced art."

June. De Kooning begins, then temporarily abandons (1951), *Woman I*.

June 27. Truman orders U.S. troops into Korea.

Summer. Noland meets Greenberg at Black Mountain.

Autumn. Still returns to New York.

October 16–November 14. Kline (age 40), first solo exhibition, Egan.

November 28–December 16. Frankenthaler sees Pollock exhibition, Parsons.

December 8–February 25, 1951. *American Painting Today, 1950* (307 participants selected by jury; prizes awarded to Karl Knaths, Rico Lebrun, Kuniyoshi, and Joseph Hirsch), Metropolitan.

1951

January 5–February 18. Gorky, memorial exhibition, Whitney.

January 11–February 7. *Seventeen Modern American Painters*, Frank Perls Gallery, Beverly Hills; Motherwell, in catalog essay, first applies term the *School of New York* to New York modernists.

January 15. "The Irascibles," *Life*. Captioned photograph of painters (Baziotes, James Brooks, de Kooning, Gottlieb, Motherwell, Newman, Pollock, Richard Pousette-Dart, Reinhardt, Rothko, Stamos, Hedda Sterne, Still, and Tomlin) who protested the Metropolitan show. "All [are] exponents of the most extreme varieties of abstract art."

January 23–March 25. *Abstract Painting and Sculpture in America* (de Kooning, Hofmann, Motherwell, Pollock, Reinhardt, Rothko, and Tomlin); symposium, "What Abstract Art Means to Me" (Alexander Calder, Davis, de

Kooning, Fritz Glarner, Philip Guston, Hofmann, Mother-
well, Reinhardt, and Tomlin), February 5, MOMA.

April 30–May 12. Roy Lichtenstein (age 27), first solo
exhibition, Carlebach Gallery.

May 14–June 2. Rauschenberg (age 25), first solo exhibition,
Parsons (selected by Parsons and Still).

May 21–June 10. *Ninth Street Show* (Elaine de Kooning,
Willem de Kooning, Frankenthaler, Hofmann, Kline, Joan
Mitchell, Motherwell, and Rauschenberg), 60 East 9th
Street.

October 15–November 3. Krasner (age 42), first solo
exhibition, Parsons.

November 12–December 1. Frankenthaler (age 27), first
solo exhibition, Tibor de Nagy Gallery.

November 13–January 13, 1952. Matisse retrospective,
MOMA.

November 16. Hess, *Abstract Painting: Background and
American Phase* (New York: Viking), first book on Ab-
stract Expressionism.

December 26–January 5, 1952. Preview *American Van-
guard Art for Paris Exhibition* (nine painters of the New
York School), Janis (selected by Leo Castelli and Janis).
Exhibition, expanded to include the work of nineteen
painters, opens February 26, 1952, Galerie de Paris.

1952

Louis moves to Washington, D.C., and meets Noland.

Rauschenberg makes black paintings.

Jasper Johns moves to New York from South Carolina.

June 16–July 3. Andy Warhol (age 21), first solo exhibition,
Fifteen Drawings Based on the Writings of Truman Capote,
Hugo Gallery.

Summer. Kline teaches at Black Mountain.

July 2. Construction begins on Philip Johnson-designed sculpture court, MOMA.

October 26. Frankenthaler paints *Mountains and Sea*.

December. Rosenberg, "American Action Painting," *Art News*. "At a certain moment the canvas began to appear to one American painter after another as an arena in which to act. . . . What was to go on the canvas was not a picture but an event."

December 14. Alfred Barr, "Is Modern Art Communistic?" *New York Times Magazine*. Answer: No, the Soviets do not like it any more than the Nazis did.

1953

Rauschenberg makes red paintings and *Erased de Kooning Drawing*.

January 11–February 7. Eleanor Ward opens her Stable Gallery, 927 West 7th Avenue, with *Second Annual Exhibition of Painting and Sculpture*, successor to the *Ninth Street Show* (Elaine de Kooning, Willem de Kooning, Gottlieb, Hofmann, Motherwell, Rauschenberg, and others).

March 16–April 11. De Kooning exhibits first series of Women, including *Woman I*, Egan. Hess describes creation of *Woman I* in "de Kooning Paints a Picture," *Art News*, March.

April 4. Louis and Noland (with Greenberg, Egan, and Kline) visit Frankenthaler's studio and see *Mountains and Sea*, then return to Washington, D.C., and begin painting together.

1954

Johns moves to Pearl Street studio.

January 11–30. *Emerging Talent* (Louis, Noland, Philip Pearlstein, and others), Kootz (selected by Greenberg).

April 6–27. Elaine de Kooning (age 34), first solo exhibition, Stable.

April 16. Army-McCarthy hearings begin.

June. Hess becomes executive editor, *Art News*.

September 15. Hilton Kramer becomes associate editor, *Art Digest*.

October 16. Walter Arensberg collection, including forty-three works by Duchamp, opens to public, Philadelphia Museum of Art.

December. Johns destroys most of his work to date and paints *Flag*.

December–January 1955. Rauschenberg exhibits red paintings, Egan.

1955

Johns paints flags, targets, and alphabets.

Rauschenberg moves to Pearl Street studio; paints *Rebus*.

April 2–3. Greenberg visits Louis and advises him to visit New York more often to see work being done there.

October. Louis destroys most of his 1955 paintings.

December. *Fortune* picks "growth stocks" among American painters: Baziotes, Kenneth Callahan, de Kooning, Joseph Glasco, John Ruitberg, Kline, Motherwell, Pollock, Reinhardt, Rivers, Rothko, Still. "Here, if he is shrewd and lucky, the tyro collector has the chance he may be able to boast, a quarter-century later, of having taken."

1956

De Kooning begins a series of color landscapes.

May 29–September 9. *Twelve Americans* (Brooks, Sam Francis, Guston, Hartigan, Kline, Rivers, and others), MOMA (Dorothy Miller, curator: "Though some of them have been associated with the movement known as abstract expressionism, no single style or theme runs through the exhibition").

June 10. Huntington Hartford announces plans to build a Gallery of Modern Art at Columbus Circle. "I don't favor extreme abstract expressionism or other extreme trends" (*New York Times*).

August 11. Pollock dies.

December 3–22. Warhol exhibits drawings of shoes, Bodley Gallery.

December 19–February 3, 1957. Pollock memorial exhibition, MOMA.

1957

Rauschenberg paints *Factum I* and *Factum II*.

January 2–19. Noland (age 32), first solo exhibition, de Nagy.

February 5–March 2. Castelli opens his gallery, 4 East 77th Street, with group show (de Kooning, Robert Delaunay, Jean Dubuffet, Alberto Giacometti, Marsden Hartley, Léger, Mondrian, Francis Picabia, Pollock, David Smith, and van Doesburg).

February 25. *New York Times* reports a 500 percent increase in the number of art galleries and volume of sales in a decade.

February 25. New York Area Research Council of City College reports on a six-month study: (a) it is almost impossible for artists to live on earnings from their work and (b) galleries pressure artists to work as Abstract Expressionists.

March 10–April 28. *The New York School: Second Generation* (Elaine de Kooning, Robert de Niro, Frankenthaler, Robert Goodnough, Hartigan, Johns, Alfred Leslie, Mitchell, Rauschenberg, George Segal, and others), Jewish Museum (selected by Meyer Schapiro).

April 24–June 16. Hofmann retrospective, Whitney.

May 6–25. *New Work* (Norman Bluhm, David Budd, Friedel Dzubas, Johns, Leslie, Louis, Marisol, Rauschenberg), Castelli.

October 25. Metropolitan opens eight new galleries for American painting and sculpture.

November 5–23. Louis (age 44), first solo exhibition in New York, Martha Jackson Gallery. Most of these paintings he later destroyed.

December 1. *New York Times* reports its poll of American museum directors concerning painters who will "last": Davis and Pollock are voted most likely to become "classics."

1958

Albers leaves Black Mountain.

Noland first paints with acrylics.

January 20–February 8. Johns (age 27), first solo exhibition, Castelli. Robert Scull buys many of the works. *Art News* reproduces *Target with Four Faces* (1955) on its January cover.

Spring. *It Is*, edited by Phillip Pavia, commences publication with articles by Elaine de Kooning, Vicente Esteban, Michael Goldberg, Pavia, and Reinhardt ("44 Titles for Articles on Artists under 45") and detachable color plates by Willem de Kooning, Guston, and Reinhardt.

April 6. Frankenthaler and Motherwell marry.

April 19–March 23, 1959. MOMA's *The New American Painting as Shown in Eight European Countries* (seventeen painters of the New York School) travels to Switzerland, Italy, Spain, West Germany, the Netherlands, Belgium, France, and England. "Organized at the request of European institutions for a show devoted specifically to Abstract Expressionism in America. . . . Even in New York we have not until now undertaken as comprehensive a survey."

May. Olitski (age 36), first solo exhibition, Zodiac/Iolas Gallery; Olitski meets Greenberg.

May 5–15. Cage exhibits musical scores, Stable.

May 15. Emile de Antonio, Johns, and Rauschenberg present a twenty-five-year retrospective concert of Cage's music, Town Hall.

June. Johnson commissions Rothko panels for Four Seasons Restaurant, Seagrams Building.

Summer. Frank Stella, graduated from Princeton University, moves to New York.

Autumn. De Antonio brings Ward to Stella's studio.

October. Kramer becomes editor, *Arts* (formerly *Art Digest*).

December. Greenberg becomes artistic adviser to French & Co.; shows Dzubas, Gottlieb, Louis, Noland, and Olitski.

1959

Pollock paintings outperform blue-chip stocks and precious metals futures; prices at auction rise 100 percent in a year (reported *New York Times*, January 1, 1960).

January 6–31. Hofmann retrospective, Kootz (Greenberg, curator).

October 4–10. Allan Kaprow presents *18 Happenings in 6 Parts*, Reuben Gallery.

October 21. Solomon R. Guggenheim Museum opens its Frank Lloyd Wright building, 1071 5th Avenue.

December 16–February 14, 1960. *Sixteen Americans* (Johns, Kelly, Leslie, Rauschenberg, Stella, Jack Youngerman, and others), MOMA (Miller, curator: "The Museum's 'Fifteen Americans' in 1952 and 'Twelve Americans' in 1956 showed a number of distinguished artists already well known to New York gallery visitors. . . . In the present exhibition it seemed desirable to include a larger proportion of new-comers to the New York scene").

1960

Olitski makes his first stain paintings.

Stella makes his first notched and polygonal paintings.

Warhol makes his first cartoon paintings.

April 21. Twenty-two artists (Edward Hopper, Moses and Raphael Soyer, and others) protest Whitney's emphasis on nonrepresentational art: "[We are] deeply disturbed by the role of museums in the contemporary art scene. . . . [The Whitney's emphasis] has resulted in conformism and a stultifying atmosphere."

July 15. Henry Geldzahler leaves Harvard University to become curatorial assistant, Department of American Painting and Sculpture, Metropolitan.

August 7. Tatyana Grosman suggests in a letter to Johns that he work in lithography, resulting by October in publication by Universal Limited Art Editions of *Target* and work on *Coat Hanger* and *0* of *0–9* series (1963).

September 27–October 15. Stella (age 24), first solo exhibition, Castelli.

October 29. Presidential candidate John F. Kennedy tells *Saturday Review* readers: "At this moment the Federal Government acts as an art patron to only one person

—the Consultant in Poetry and English to the Library of Congress.... I think we can do better than that if only by alleviating the unfair tax burden borne by writers, painters, and other creative artists. They may exist on small incomes for years to perfect their skills, and then be plundered by the Treasury in a single year of plenty."

1961

Noland moves to New York.

Rauschenberg joins Merce Cunningham Dance Co. as lighting director and stage manager, having designed costumes and/or decor for fourteen productions since 1954. (Johns, Stella, Warhol later design for Cunningham productions as well.)

Sculls buy James Rosenquist's *Four 1949 Men* ($250) and *The Light That Won't Fail II (No. 4)*.

January 18–March 12. Rothko retrospective, MOMA.

June. French & Co. closes its contemporary art department.

June 8. Peggy Guggenheim sues Krasner for $122,000, charging that she and Pollock failed to turn over works in accordance with agreements of 1945 and 1946.

December 1–31. Claes Oldenburg offers more than 100 sculptures for sale in The Store (sponsored by the Green Gallery; Richard Bellamy, director).

1962

Segal casts Geldzahler for *The Farm Worker* (1962–63).

Stella paints *Jasper's Dilemma* (1962–63).

Warhol paints Campbell's soup cans and other consumer images.

Jim Dine (Jackson Gallery), Robert Indiana (Stable), Lichtenstein (Castelli), Oldenburg (Green), Rosenquist

(Green), Warhol (Stable), and Tom Wesselmann (Green) all show Pop paintings in solo exhibitions.

May 13. Kline dies.

Spring. Hofmann paints *Memoria in Aeterne—Dedicated to Arthur Carles, Arshile Gorky, Jackson Pollock, Bradley Walker Tomlin, Franz Kline*.

August 21. MOMA bars lending exhibitions to institutions that practice racial discrimination.

September 7. Louis dies.

October. Philip Leider becomes managing editor, *Artforum*.

October 16–November 10. Louis posthumous exhibition, Andre Emmerich Gallery (and every year, except 1963, through 1968).

October 31–December 1. *New Realists* (Lichtenstein, Rosenquist, Wayne Thiebaud, Warhol, and others), Janis. Following by two months Walter Hopps's show *The New Painting of Common Objects* at the Pasadena Museum, this was the first important Pop art survey in New York. Hess described it as "a tempest in a fur-lined teacup" (*Art News*, December).

December 19–February 12, 1963. Gorky retrospective, MOMA.

1963

De Antonio completes his first film, *Point of Order*, based on the Army-McCarthy Hearings.

De Kooning builds studio in The Springs.

Warhol paints *Ethel Scull 36 Times* and makes first films.

June 6. Baziotes dies.

November 4–23. Larry Poons (age 26), first solo exhibition, Green.

1964

Johnson commissions works by John Chamberlain, Indiana, Lichtenstein, Rauschenberg, and Warhol (*Thirteen Most Wanted Men*) for New York State Pavilion, World's Fair.

February 26. Revenue Act of 1964 revises older tax laws by extending the base period for income averaging from three to four years and by instituting other provisions favorable to artists.

March 16. Hartford opens his Gallery of Modern Art.

Spring. Olitski makes his first spray paintings.

August 4. U.S. Senate passes Gulf of Tonkin resolution, enabling President Johnson to wage offensive war against North Vietnam.

1965

Marisol carves *Henry* [Geldzahler].

Noland makes his first horizontal stripe paintings.

March 30. De Kooning sues Janis for $150,000, charging the gallery sold paintings to itself at arbitrarily low prices; Janis prepares countersuit, claiming de Kooning sold works privately, despite gallery contract, and that he is in arrears on studio mortgage, which Janis guaranteed.

April. Geldzahler, *American Painting in the Twentieth Century* (Greenwich, Conn.: New York Graphic Society).

May. Peggy Guggenheim drops suit against Krasner.

May 12. Scull buys Rosenquist's *F-111* ($60,000).

September 25. Lyndon Johnson signs act establishing National Endowment for the Arts (NEA).

1966

Geldzahler becomes director, visual arts program, NEA.

February 17. Hofmann dies.

June 18–October 16. Venice Biennale (Geldzahler, serving as consultant to the Smithsonian Institution, selects works by Frankenthaler, Kelly, Lichtenstein, and Olitski).

September 27. The Whitney opens its Marcel Breuer building, 945 Madison Avenue.

November 23–January 15, 1967. Reinhardt retrospective, Jewish Museum.

1967

Motherwell makes his first Open paintings.

Stella makes his first Protractor paintings.

January. Stella, appointed artist-in-residence at University of California, Irvine, refuses to sign state's loyalty oath and thereby forgoes the appointment.

February 8–May 22. Rauschenberg makes his first prints, *Booster* and *Seven Studies*, for Gemini G.E.L.

March 20. Geldzahler becomes curator, Department of Contemporary Art, Metropolitan.

June. *Artforum* moves editorial offices from Los Angeles to New York.

June 16. Janis announces the gift of his collection to MOMA.

August 30. Reinhardt dies.

1968

January 10. With funds from the sale of works from the Janis collection, MOMA buys Pollock's *One* ($300,000).

January 29. NLF and North Vietnamese launch Tet offensive against U.S. ground forces.

June 4. Valerie Solanis shoots and seriously injures Warhol.

June 5. Sirhan Sirhan shoots Robert F. Kennedy.

October 2. Duchamp dies.

1969

February 20–April 6. Frankenthaler retrospective, Whitney.

March 6–April 27. De Kooning retrospective, MOMA.

March 25–April 19. Newman, first comprehensive exhibition since 1959, Knoedler.

June 11. Art Workers Coalition demands participation in control of MOMA, free admissions policy, and a gallery set aside for the work of black artists.

July. Duchamp's final work, *Etant Donnés: 1° la chute d'eau, 2° le gaz d'éclairage* (1946–66), installed at Philadelphia Museum of Art.

October 18–February 1, 1970. *New York Painting and Sculpture: 1940–1970*, Metropolitan (Geldzahler, curator).

1970

February 25. Rothko commits suicide.

March 26–May 31. Stella retrospective, MOMA.

September. Rauschenberg establishes Change, Inc., to distribute emergency funds to artists.

November 14–February 14, 1971. *Masterpieces from Fifty Centuries* (402 works from the museum's collection, including works by four modernists: Gorky, Hofmann, Louis, and Pollock), Metropolitan.

November 18. Works by modernists from the collections of the Sculls, Donald and Lynn Factor, and others bring more than $1 million at auction, Parke-Bernet. Major purchaser, Rudolph Zwirner, a dealer from Cologne, buys Lichtenstein's *Big Painting No. 6* (1965) for $75,000, a record auction price for a work by a living American

painter (within one week he had sold it to a German museum for $90,000) and Oldenburg's *Stove* (1962) for $45,000, a record auction price for a work by a living American sculptor. Zwirner told the *New York Times* (November 27), "'Americans may have let this art go because . . . they are tired of the art of the sixties and are sated with pop.' Perhaps they have 'never had complete faith in it. They have always been suspicious of contemporary art, except for a few. Despite the New York School and pop, they still think they're too young a culture to create a true art.'"

INDEX

Italics indicate first-person commentary.